Salvaged

the Art of Jason Felix

Salvaged: *the Art of Jason Felix*

Created and produced by: **Jason Felix**

Design by **JS Rossbach**

ISBN-10: 1-933784-33-4

ISBN-13: 978-1-933784-33-5

Correspondence:

1284 48th Ave.

San Francisco, CA 94122

USA

www.jasonfelix.com

jfsalvaged@hotmail.com

For licensing or other information, contact the Artist: **Jason Felix**

Library of Congress Cataloging-in-Publication Data available.

 REPLANTED PAPER

Palace Press International, in association with Roots of Peace, will plant two trees for
each tree used in the manufacturing of this book. Roots of Peace is an internationally
renowned humanitarian organization dedicated to eradicating land mines worldwide
and converting war-torn lands into productive farms and wildlife habitats. Together,
we will plant two million fruit and nut trees in Afghanistan and provide farmers there
with the skills and support necessary for sustainable land use.

Printed and bound in China

10 9 8 7 6 5 4 3 2 1

INSIGHT
EDITIONS

Published by Insight Editions

17 Paul Drive

San Rafael, California 94903

800.688.2218

415.526.1370

Fax: 415.526.1394

www.insighteditions.com

lvaged

rt of

on Felix

INSIGHT
EDITIONS

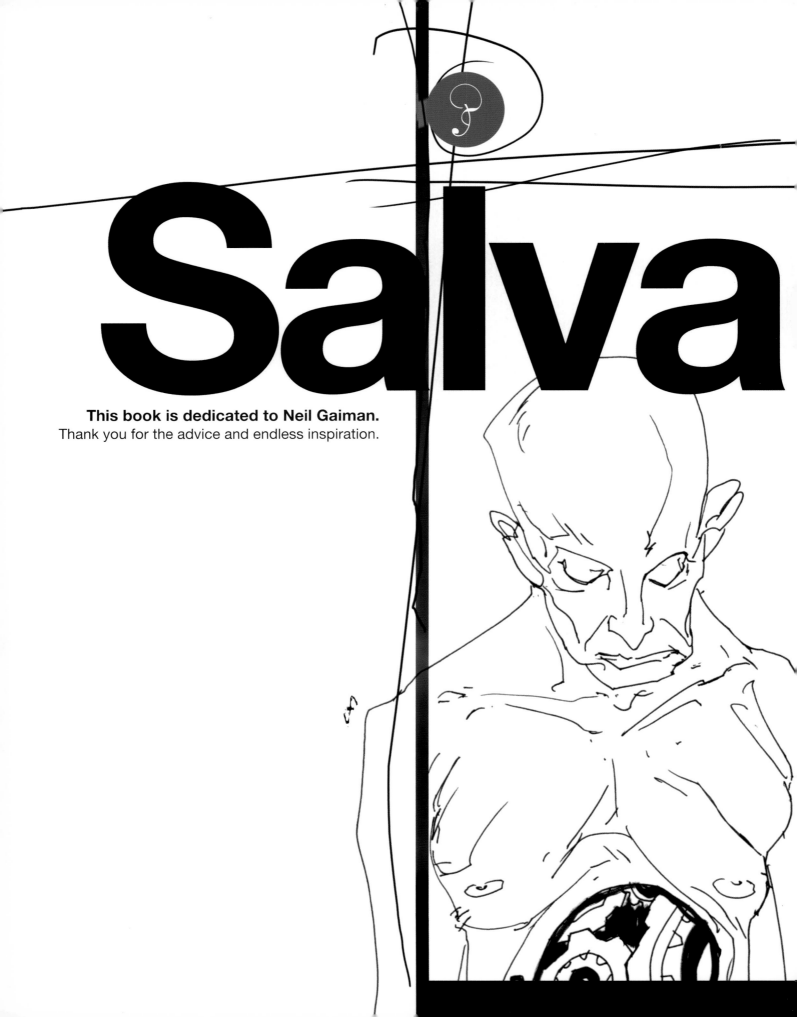

Salva

This book is dedicated to Neil Gaiman.
Thank you for the advice and endless inspiration.

geo

the Art of **Jason Felix**

table of **Contents**

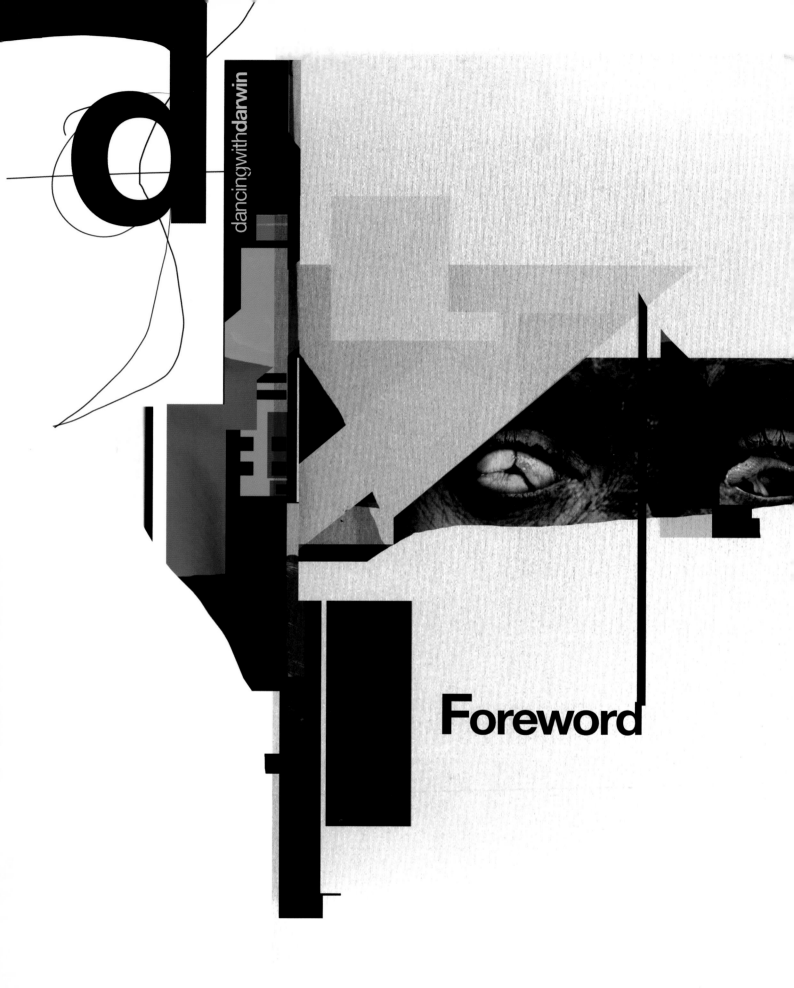

Foreword

What's so attractive about a lived-in, dystopian, at times terrifying, weird-sexed, twist-wired future with alien plumage? Well, the art that comes from it is pretty astonishing. Jason Felix, with an increasingly deft touch, has been shoplifting artifacts and whole entities from the skyscrapers and back alleys of the scariest parts of Tomorrow Town. I can't seem to take my eyes off of the weird wonder of his visionary assumption.

Were I to attempt in word or story one of Felix's pictures, the result would likely be a Frankensteinian cobble of grotesque anatomies, both organic and industrial, that grate against the ear and sound as if they should never ever go together. Which makes what he's done so much more sublime. Elements that should collide and clash, bits that would seemingly violate each other's meaning and intent, come together in a lyric assembly. Things bizarre and spooky, wrong-headed and to be instinctively avoided, have now been threaded into an elegant visual syntax. And while you're not relieved of an almost alien wrench to reality, Felix somehow reassures that this can all be negotiated in beauty.

I don't like all of it. There are pictures that I wish would go away. But he has convinced me he's seeing something real. And so, not just for the pictures that strike me as beautiful but also for the ones that are hard to bear, I begin to have real admiration for the artist who takes such risks. He's not going safe places, he's not doing safe pictures...but I don't think any art worth the time is ever safe; if it's got anything going for it, it's dangerous to someone, somewhere.

But the person it's most dangerous to is the artist himself. He may not at first realize it but the longer he endeavors in some visual frontier, the stronger he's going to have to become, or he can be devoured by the world he's entered. Was it Nietzsche who wrote, "Beware of peering into the abyss, for while you look, the abyss is looking back at you"?

When handling not just elements of fetishism, addiction, sexual definition, but also looking at the evolution of such things, you'd better have character equal to the task. The rewards are terrific if you can. So far, Felix is too eclectic and on the move to evidence the debasing schtickism of a weak artist caught in a web of mere repetitive titillation and shock pedaling. So often there's a sense of unearthly beauty and awe, or pathos and identification with the mute and suffering.

Human beings are becoming fabulous and strange...and it's happening very fast. Felix is there. That's where he's looking and for all the scary bits you can also see the excitement, the sense of stunning transformation and wild beauty.

He leaves you with no easy answers about the fate of humankind as it begins to direct its own evolution. He depicts both the base and the grand as we drive our own mutations beyond Darwin and marry our machines (even as they begin to awaken). Neither our darkness nor our brilliance is left behind.

It's good to have someone with fantastic visual agility to get us a step or two into the process just before it freaks us out.

Rick Berry
Boston

My perception of the world changed after I purchased a Nikon digital camera. It profoundly altered the way I see. The ability to snap infinite pictures and not worry about film is very gratifying. It brought out the inquisitive nature within me, and I discovered a deep passion for snapping photos, especially textures. It's hard to explain, but there is more than one image within each picture. Patterns emerge, colors vibrate and abstract shapes turn into ideas. It's the "art" of seeing. San Francisco is a great breeding ground for textural diversity. Consider that within six miles you have a beautiful beach, a meticulously maintained park, segregated ethnic neighborhoods, a downtown business district and a sizable homeless population. Slap that all up with a sliding scale of income wages and WHAM!...what do you get? A stunning landscape of textures and people waiting to be discovered.

I've spent countless hours roaming the streets of San Francisco and photographing everything. Layers of peeling paint from buildings, a broken television on the sidewalk, an outlandish-looking gentleman waiting for the bus, a dirty garbage truck...all uniformly inspiring. There is beauty in everything and in everyone if you allow yourself to see it. A very good example is watching a child exploring his or her environment. He will sit on the ground to get a better look at, let's say, a flattened piece of bubble gum. What does that child see that we do not? Maybe it's the gummy imprint of a shoe or the pink gum against the gray, colorless pavement. Perhaps the child simply likes to eat dirty, sandy, stepped-on gum. Who knows, but therein lays the beauty. When I get behind the camera, I look at everything with an open mind and a clear head, geared toward exploring the world with great, childlike enthusiasm. I cannot count how many times I found myself sitting on the ground, losing track of time while snapping an amazing texture.

My oldest muse has been anything industrial, in particular the interplay between man and machine. I've captured a myriad of cars, engines, warehouses, factories, car lots, repair stations and junkyards. Most of the objects were one step away from being dismantled, demolished or retired to a landfill. In essence, taking, recombining and recycling the photos was my way of saving these obsolete objects from being completely destroyed. The human body happened to be the perfect canvas on which to collage and refashion these often disparate industrial elements.

The evolution of machines and our dependency on them has grown so vastly in a short amount of time. Without hesitation, we embrace technology with excitement and wonder. I'm amazed and yet frightened by it all. On one side, there is a utopian mind-set of how wonderful life will be as our bodies slowly merge with the machines on a molecular level, perhaps becoming immortal. On the other side, there is something abnormal about the merger that defies the law of nature. "Man" is officially forcing its own evolution. No longer science fiction, we are merging with machines at an astonishing rate. Once we go forward, there is no going back.

With my camera I am documenting "The Present" and with my paints I am envisioning "The Future." All of these pieces, these "scraps," are visual documents. These dirty, rusty, dented, cracked, chipped, scratched, imperfect castaways are all pieces of a story waiting to be told anew...to be *Salvaged*.

Jason Felix
San Francisco

The Gallery

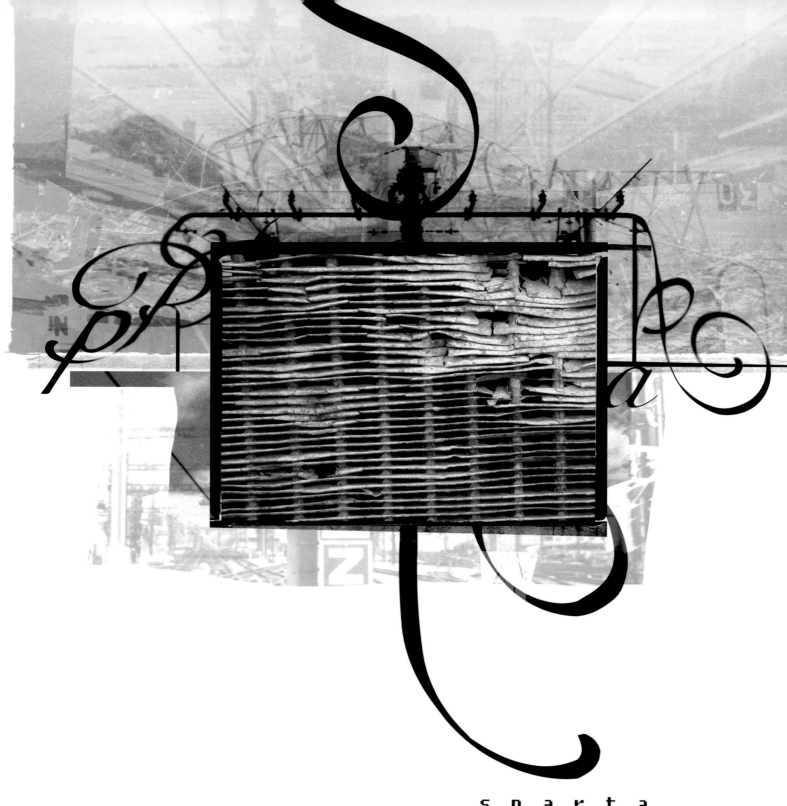

sparta

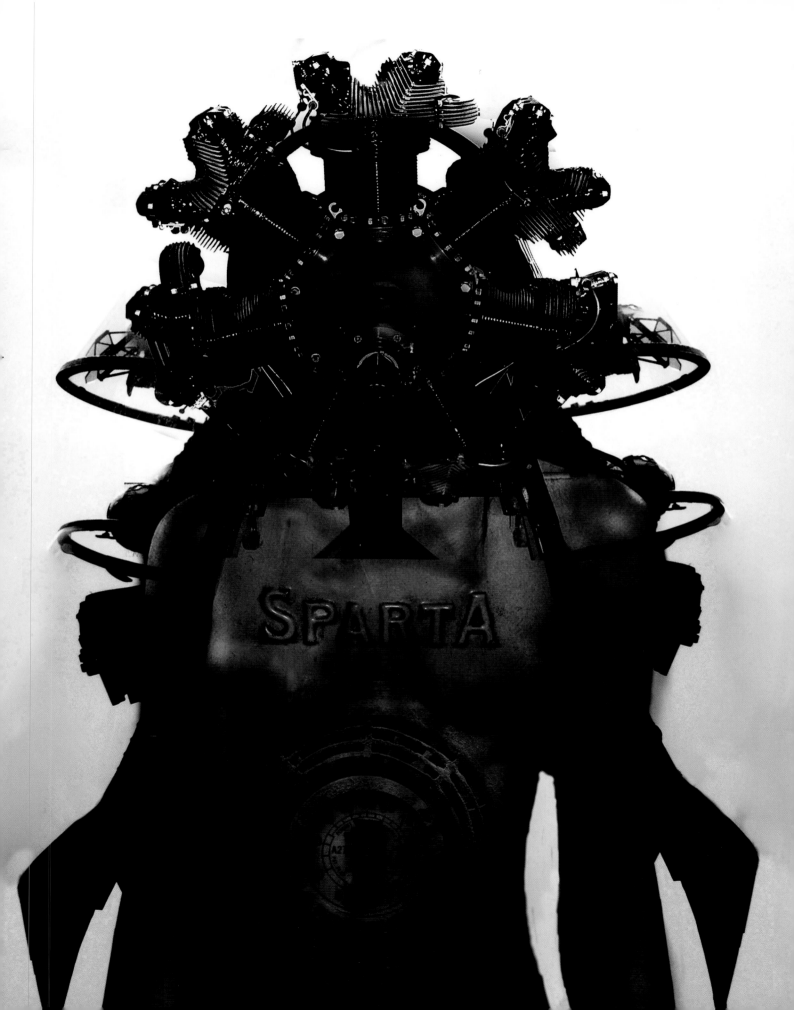

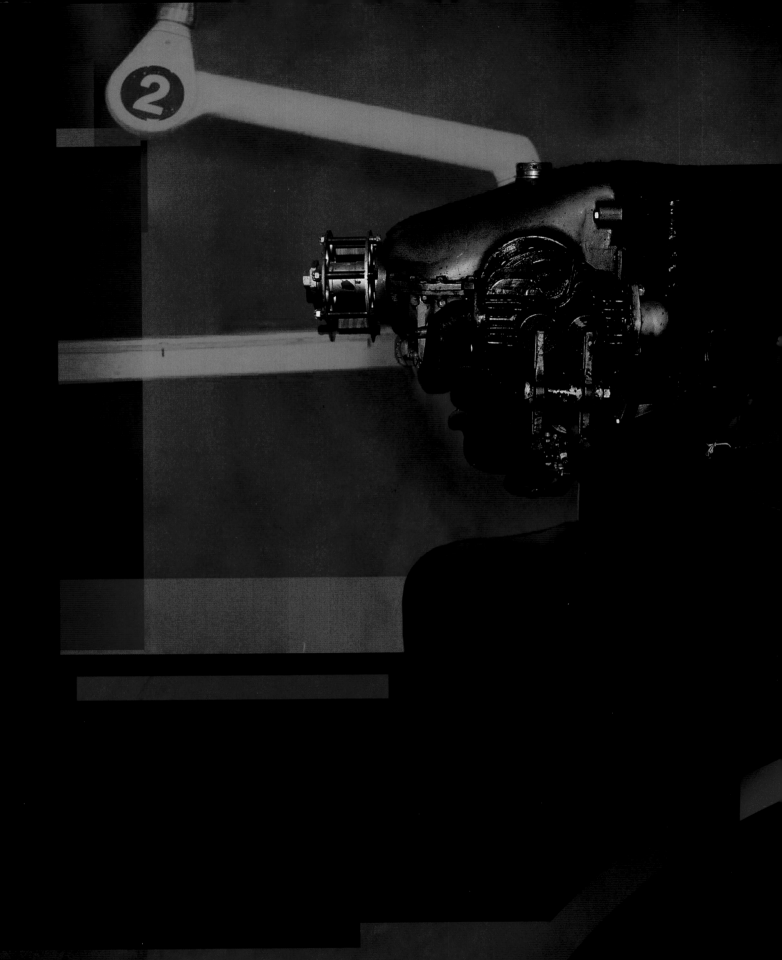

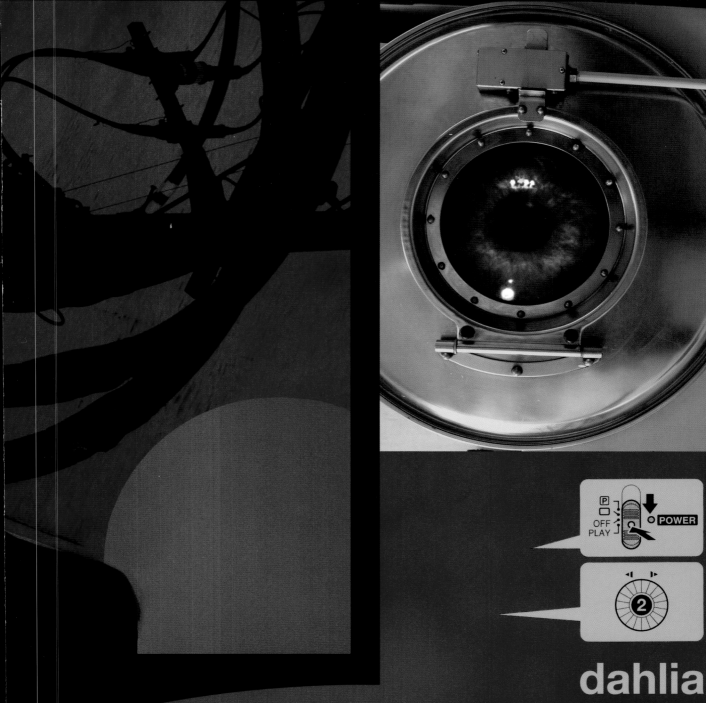

dahlia

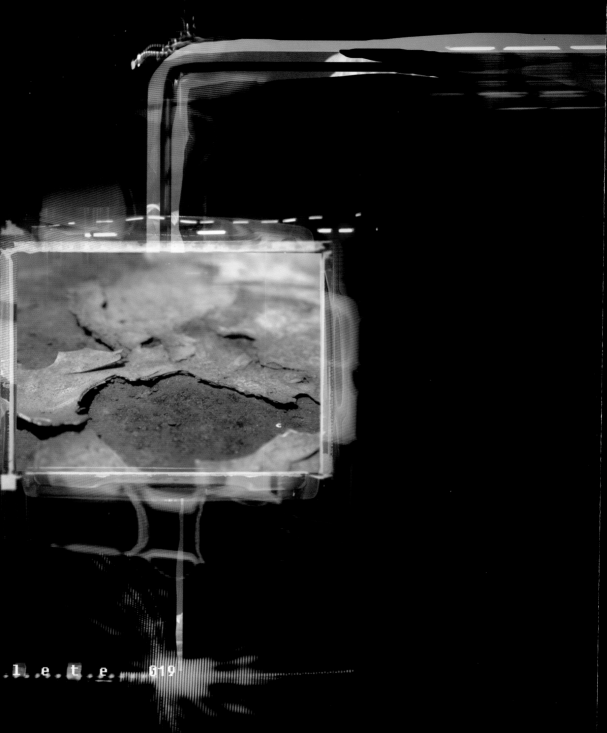

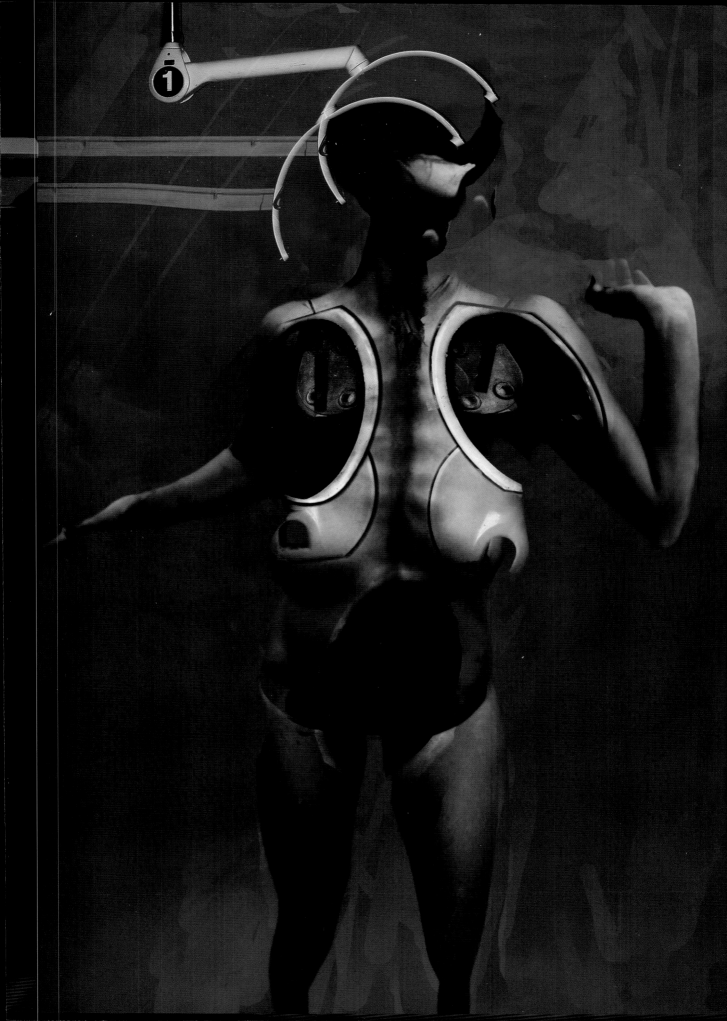

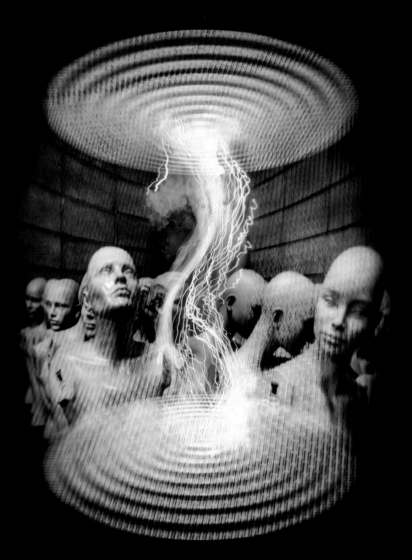

cyberotica

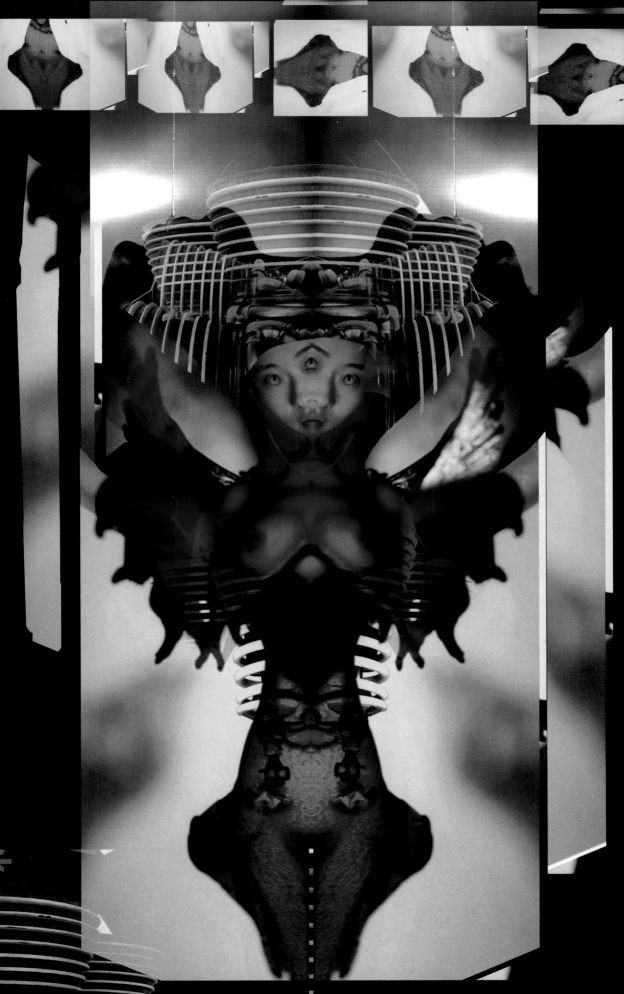

hermes

6 6
6 6
6 6
6 6
6 6
6 6
6 6
6 6
6 6

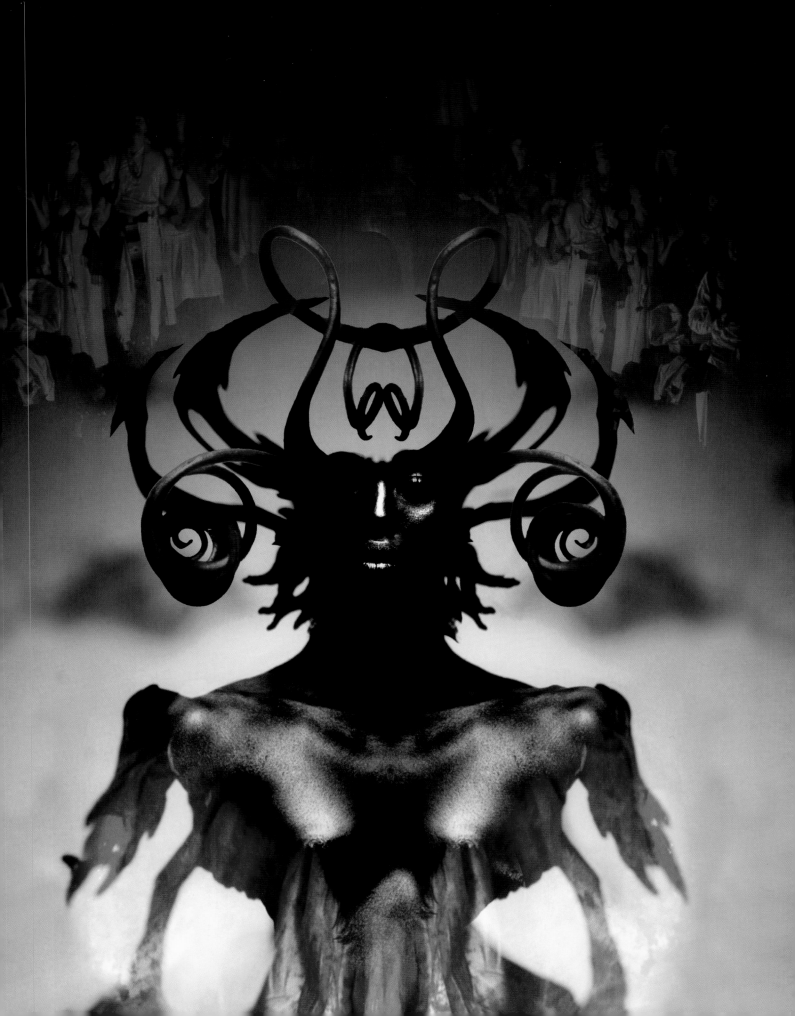

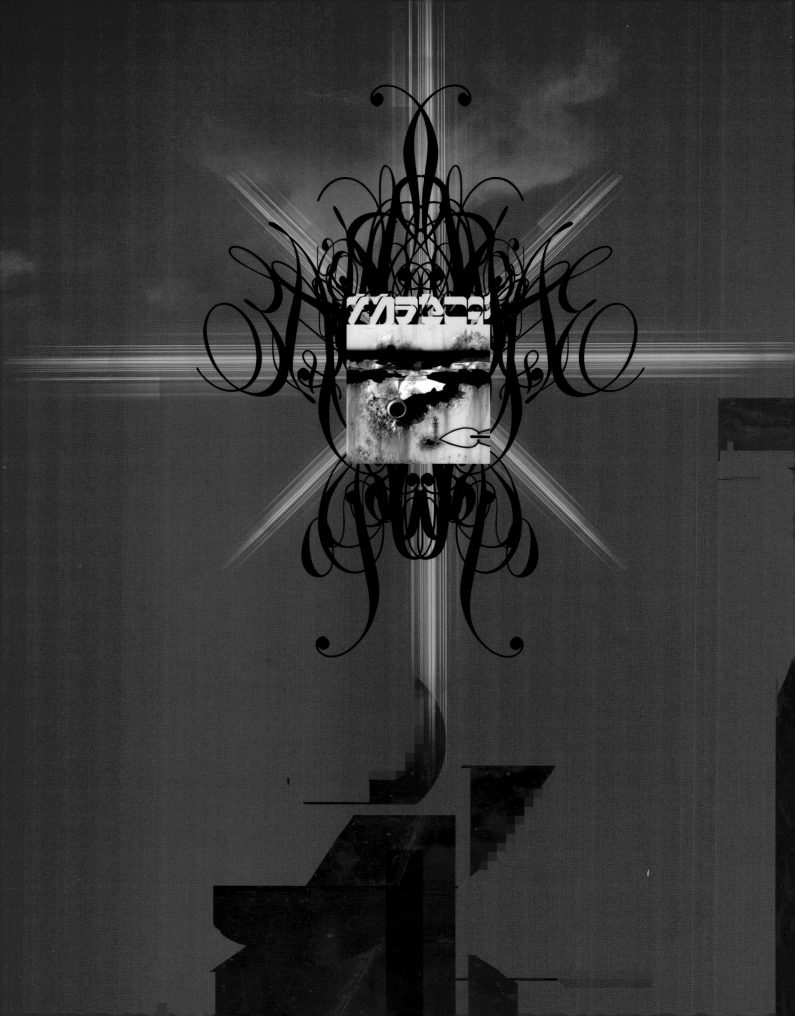

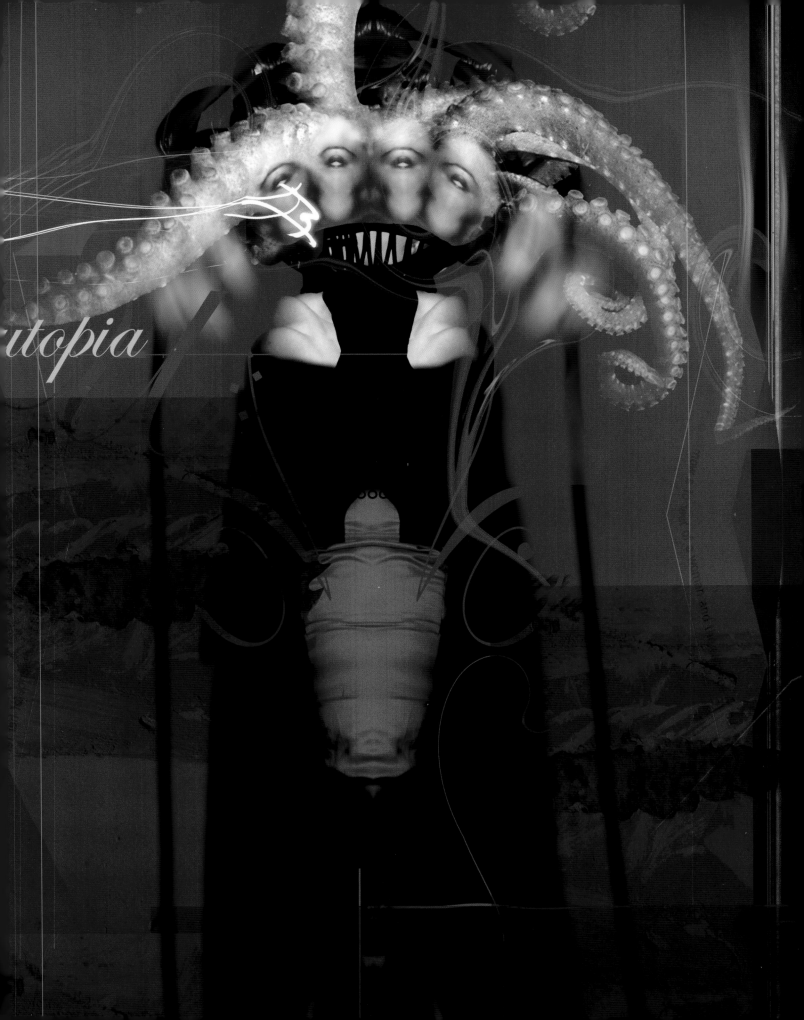

utopia

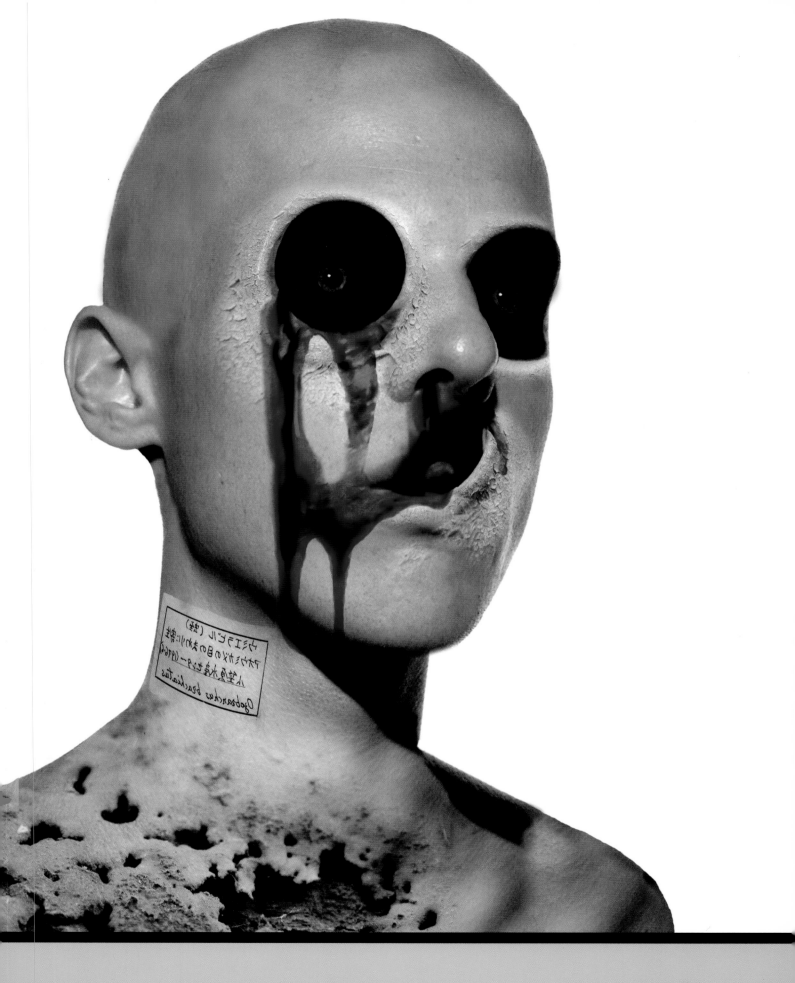

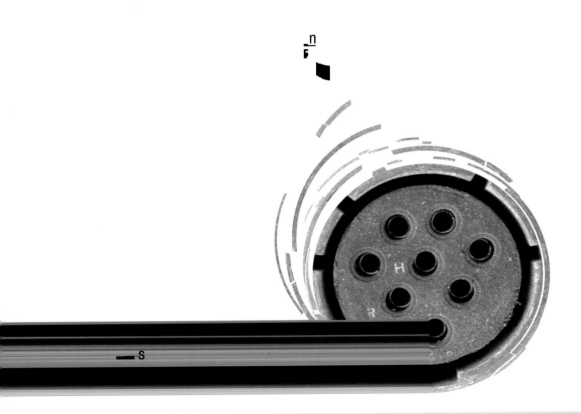

tsutcu

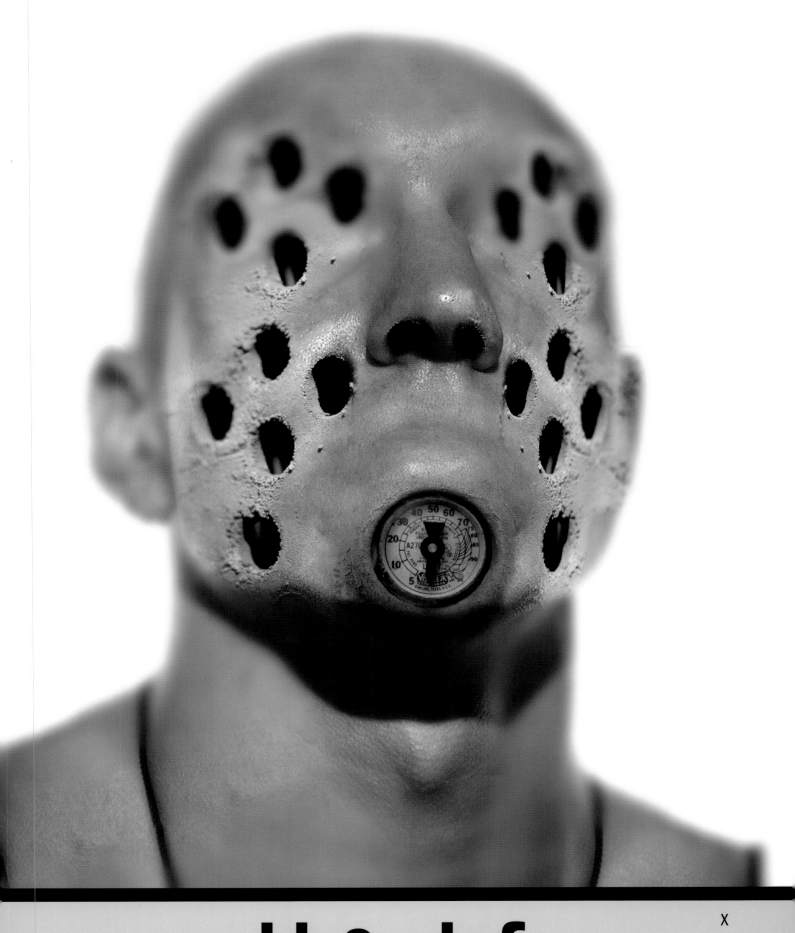

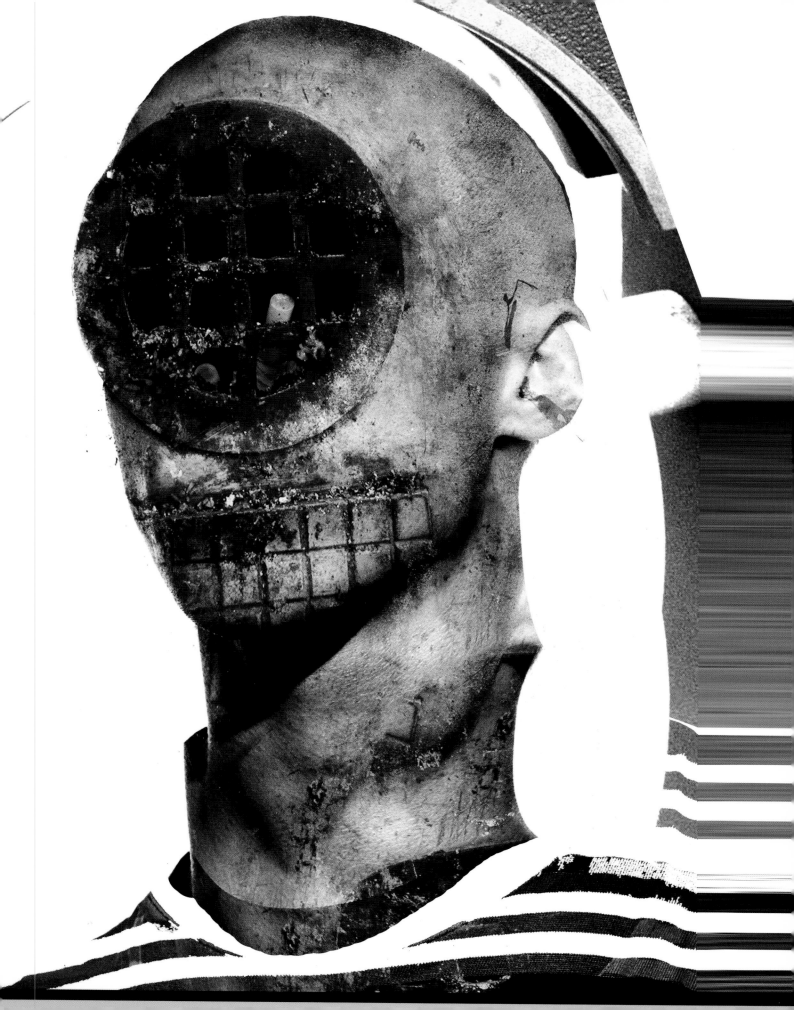

X

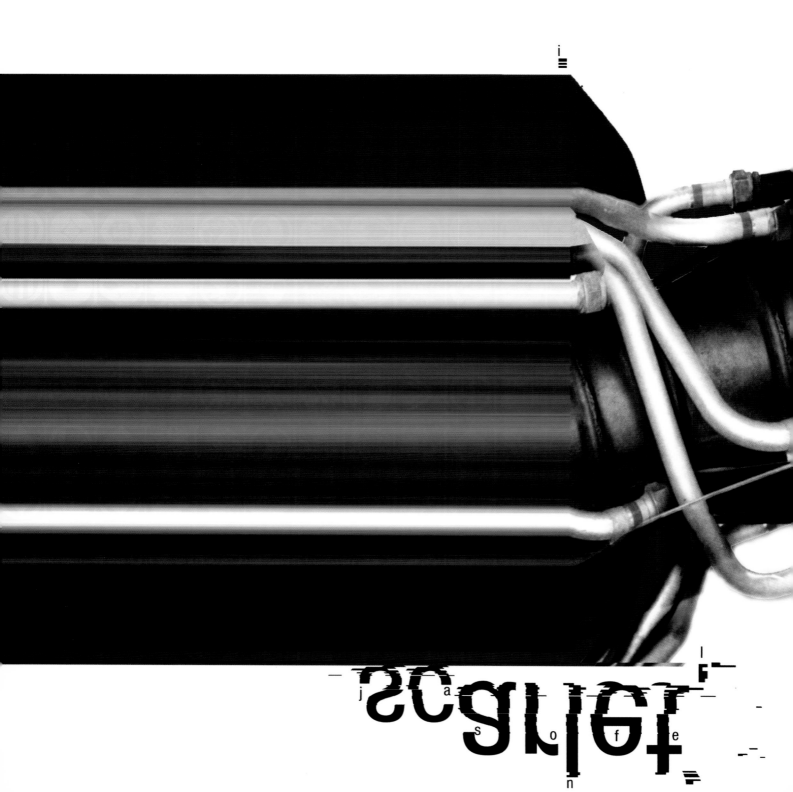

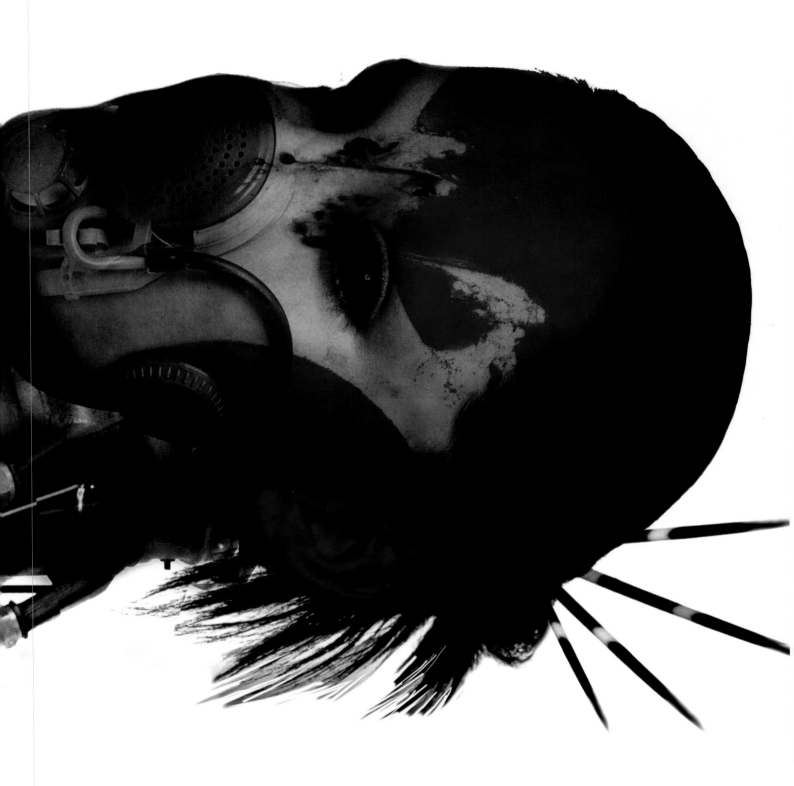

l i

e

n
f

X

s
a

o

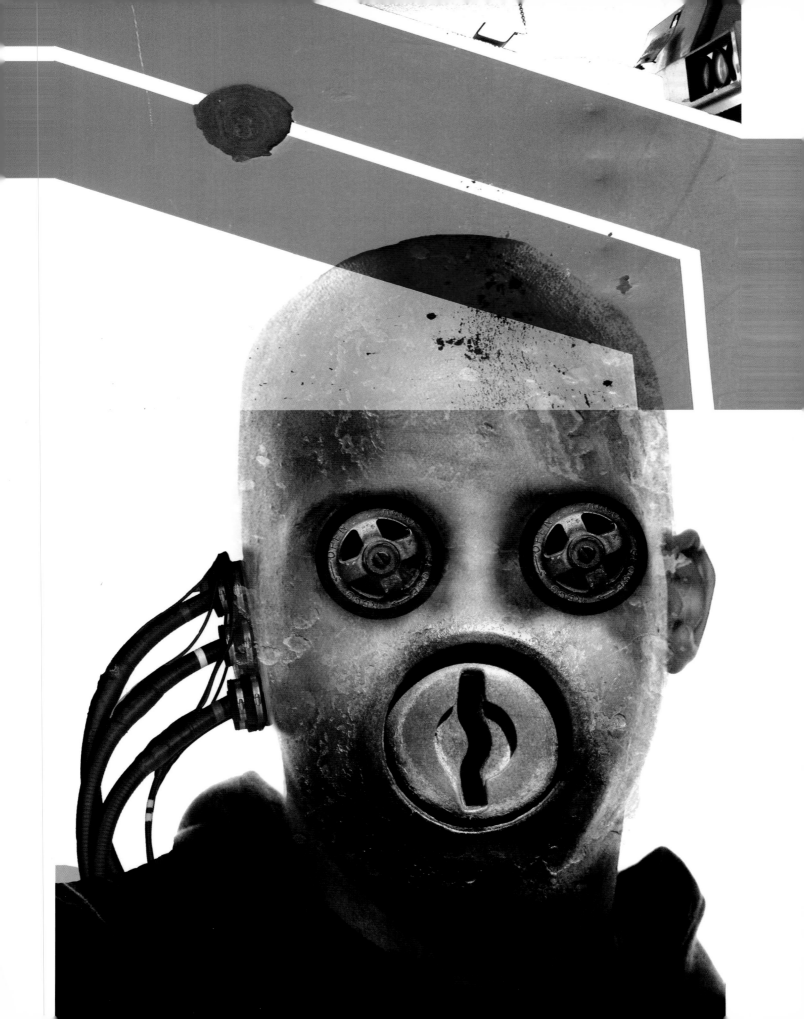

proxy

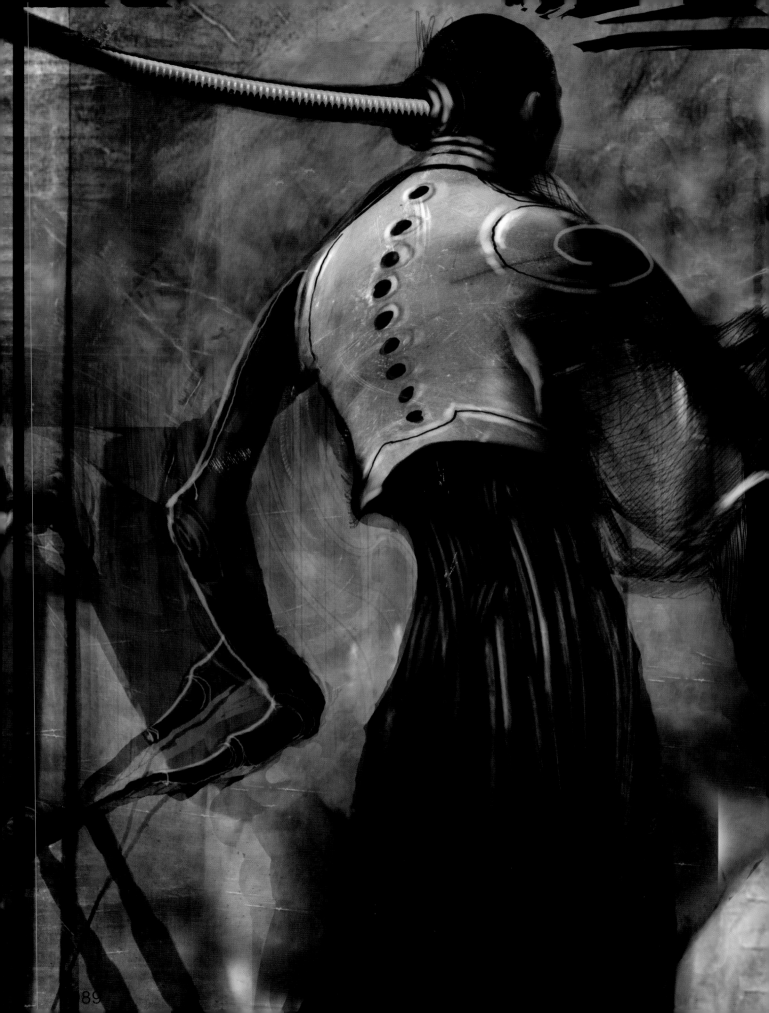

adrift

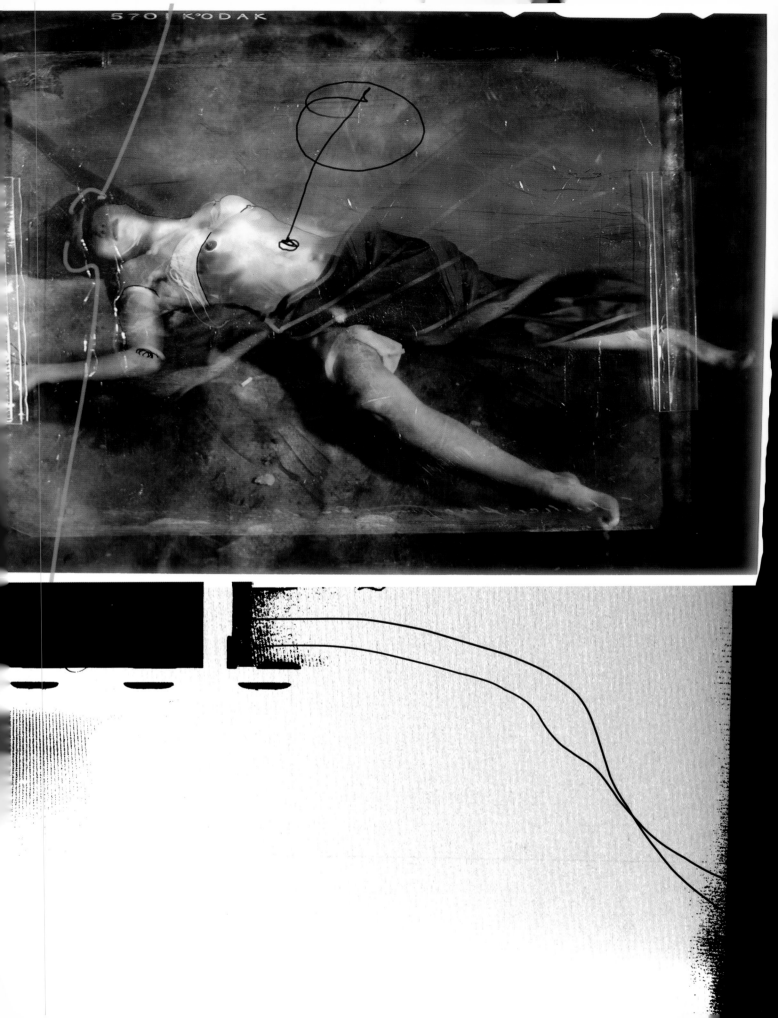

clandestine

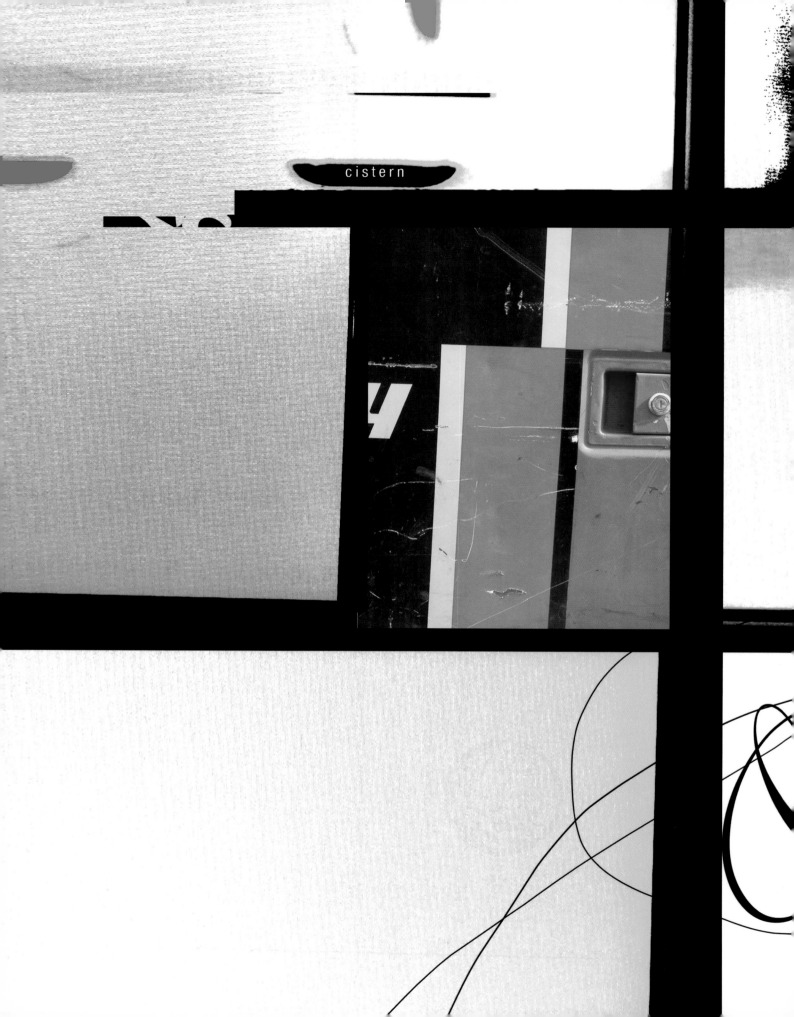

cistern

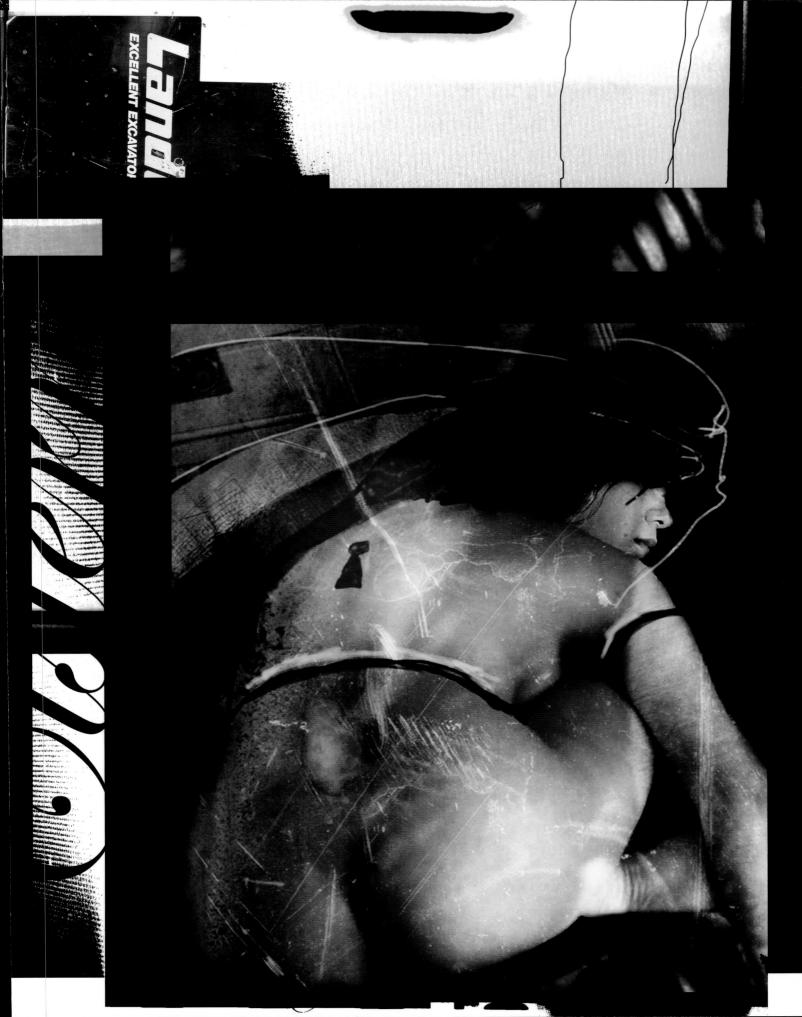

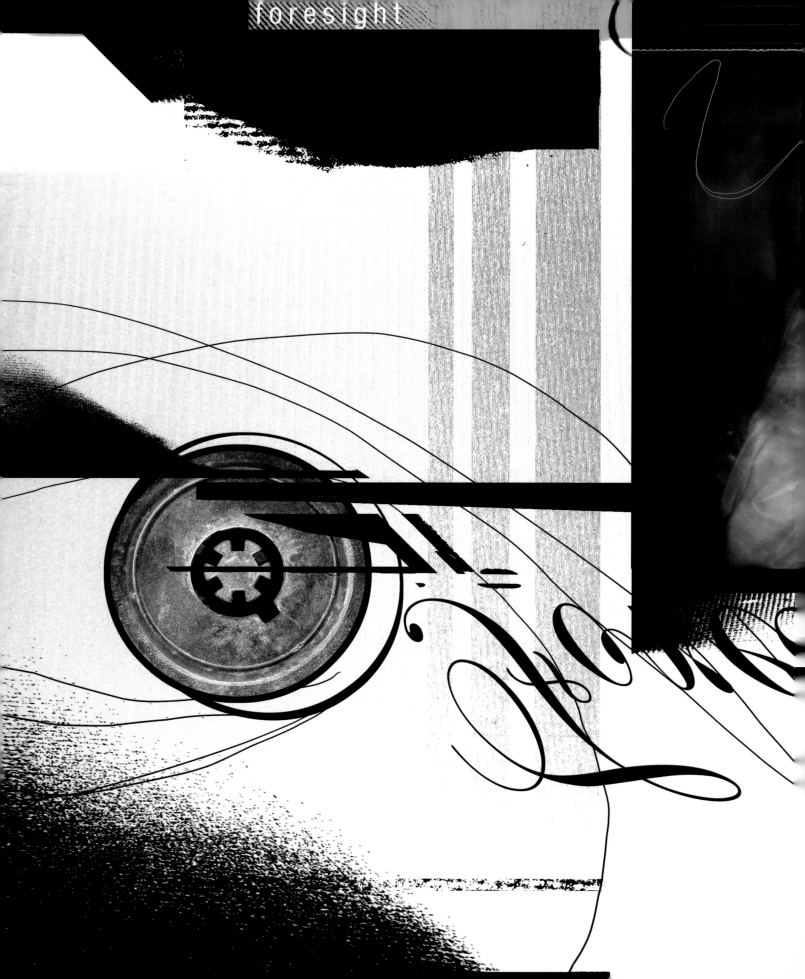

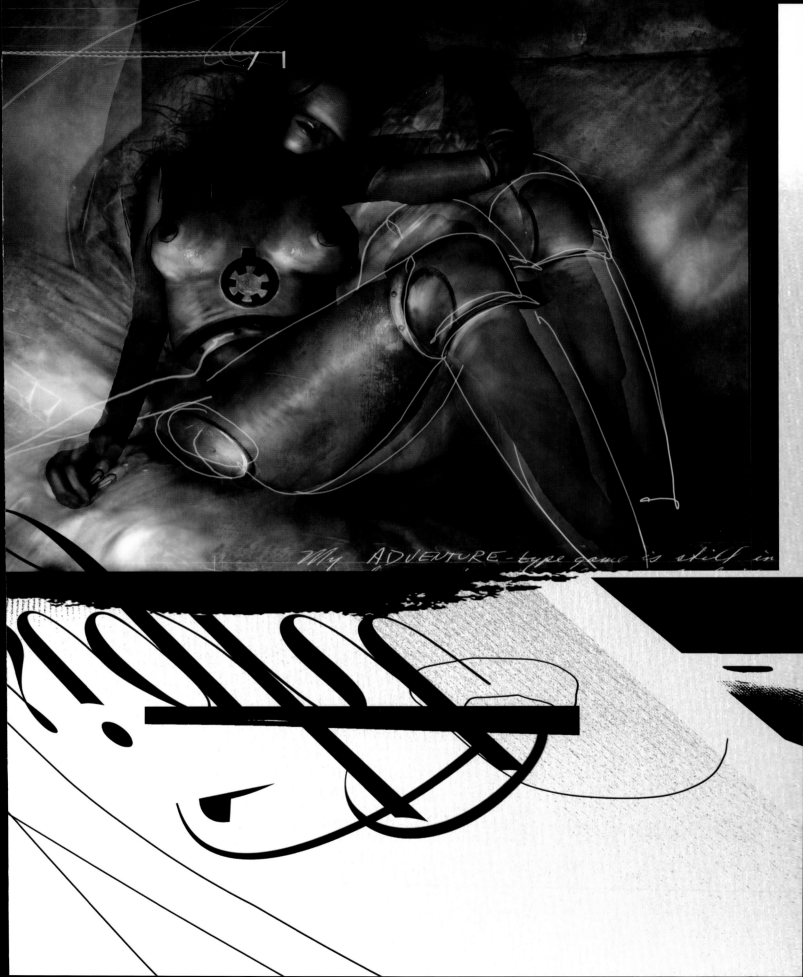

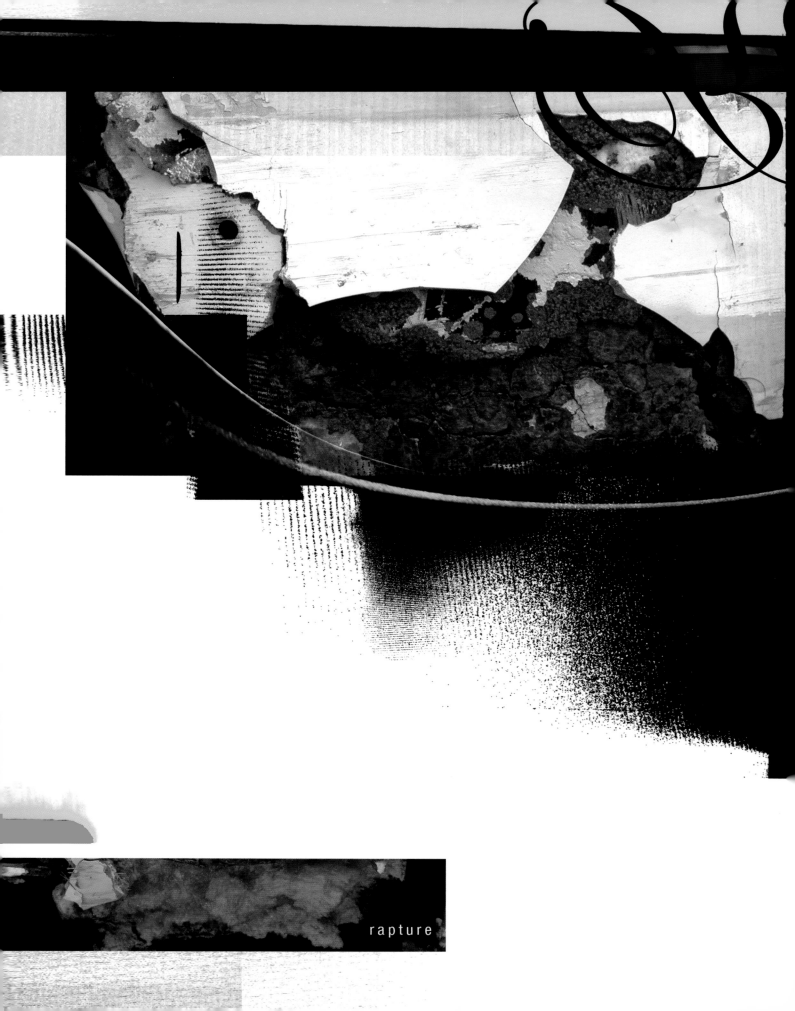

rapture

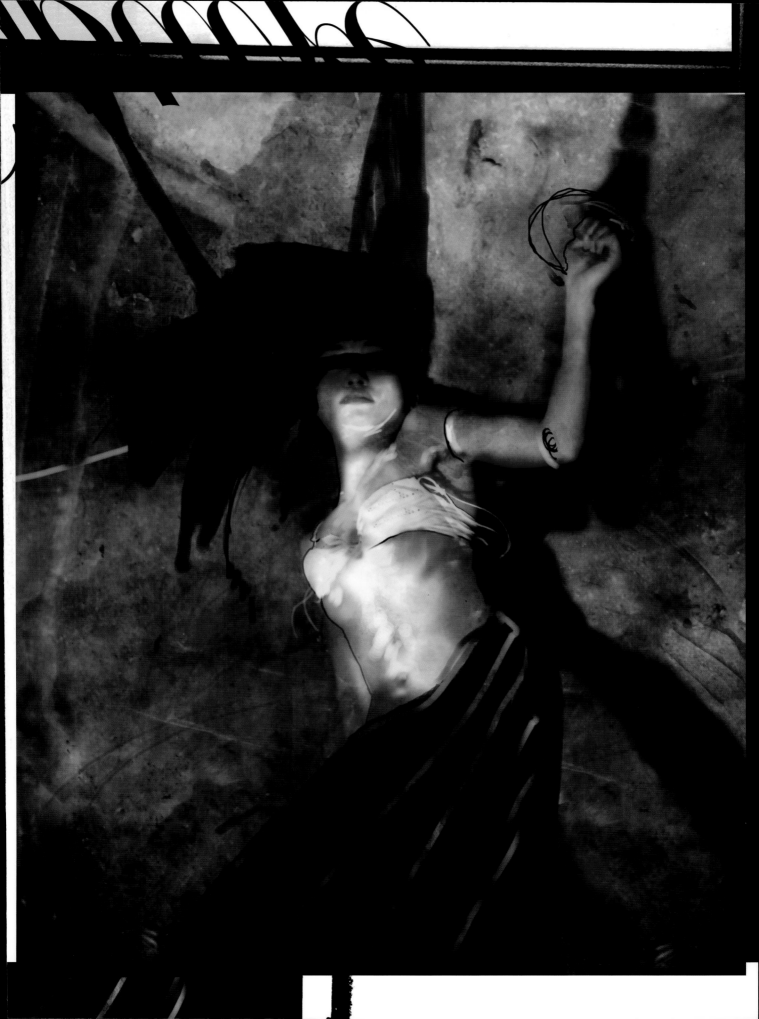

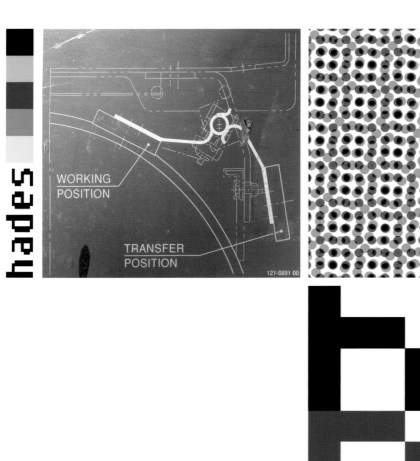

WORKING
POSITION

TRANSFER
POSITION

121-0891 00

hades

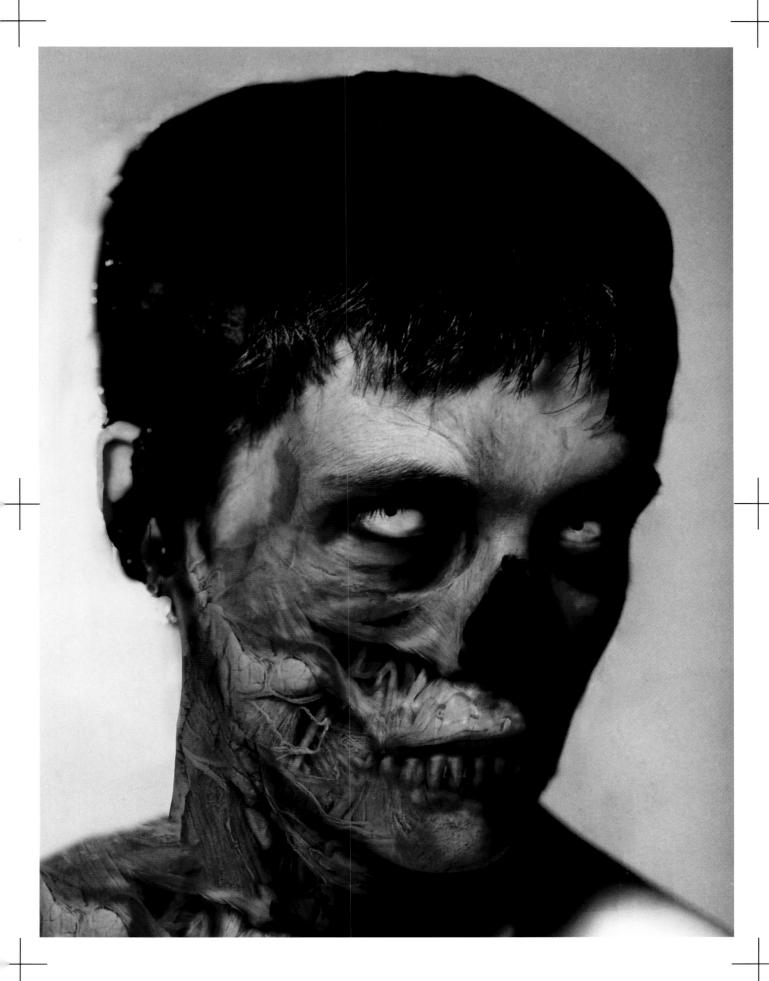

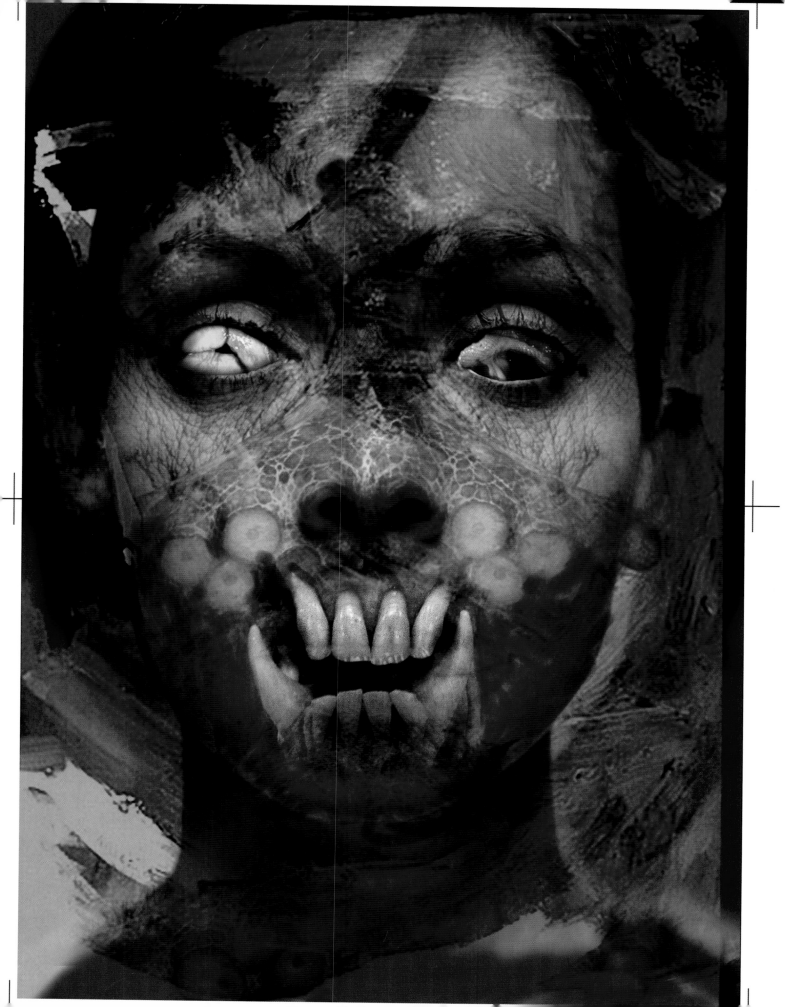

golconda

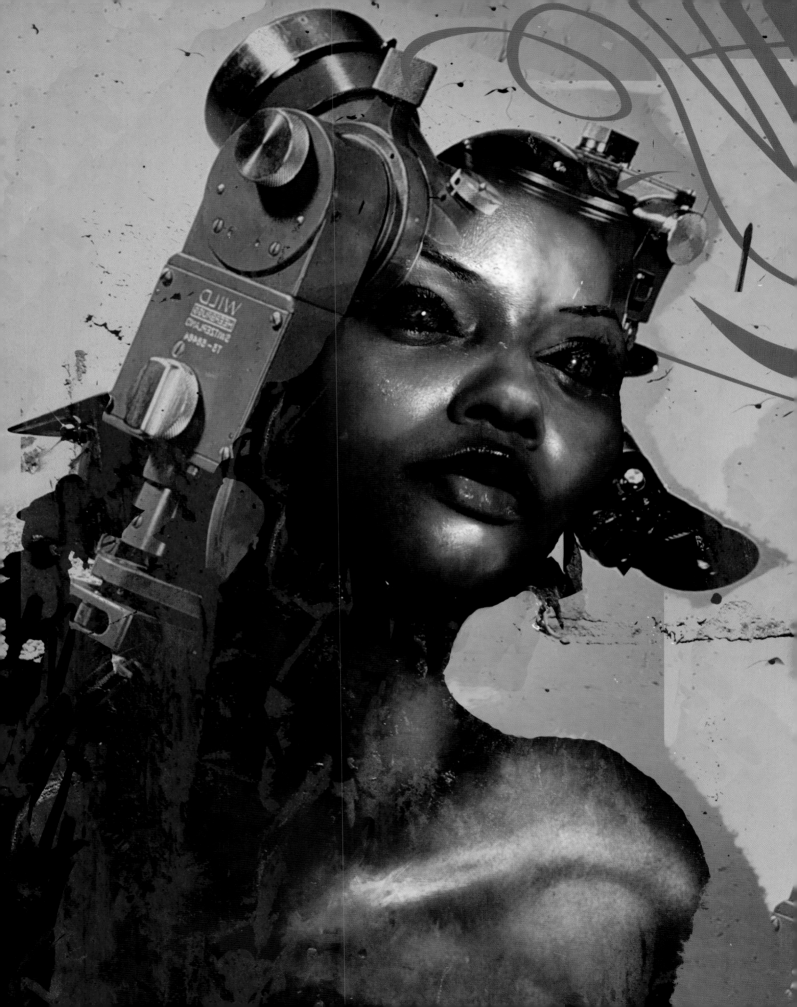

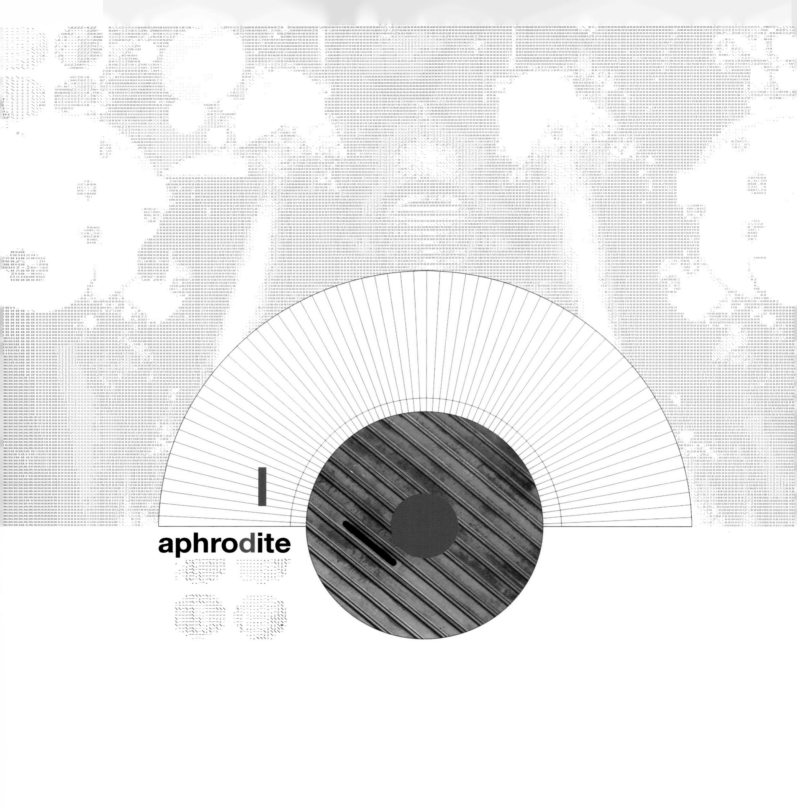

aphrodite

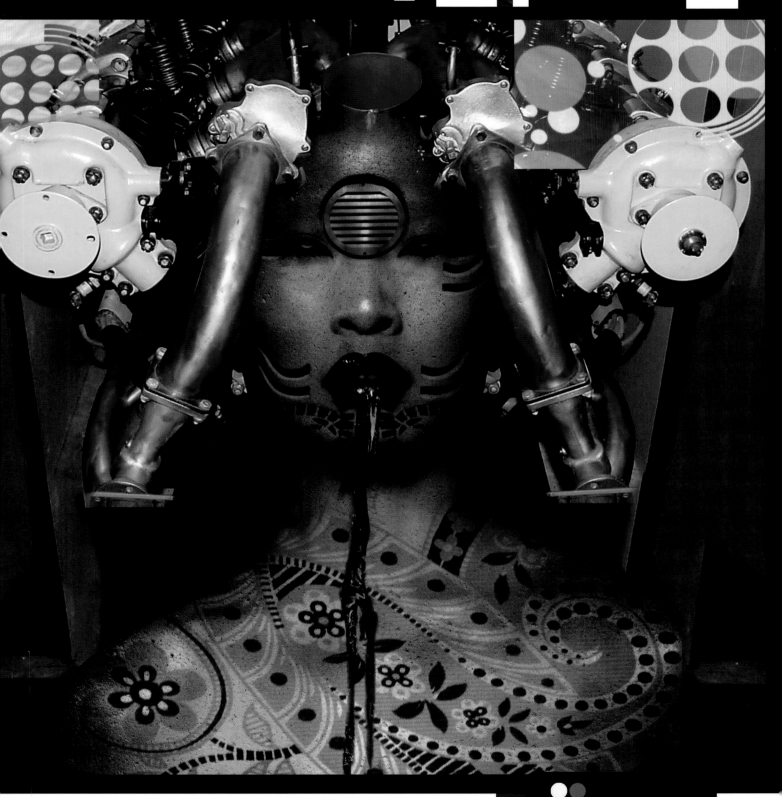

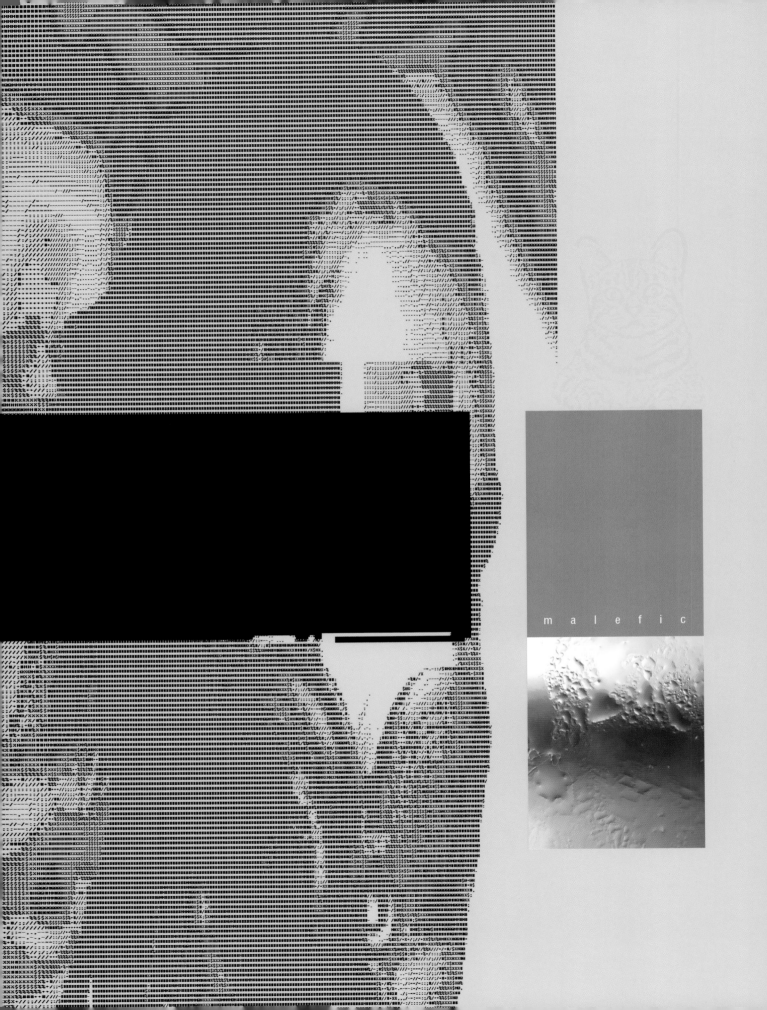

malefic

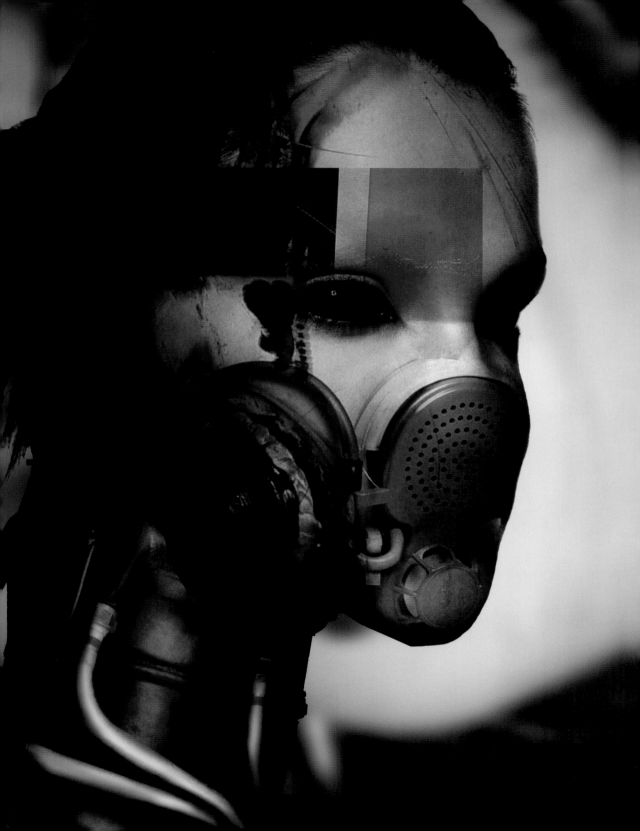

f l i g h t l e s s

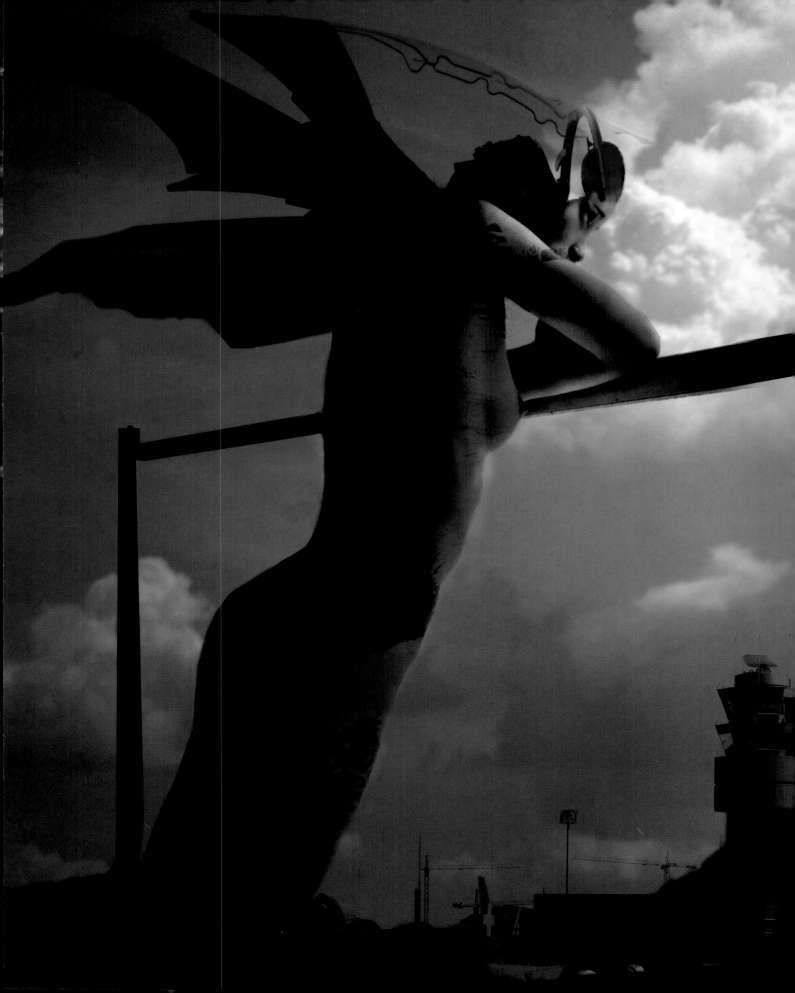

chartreuse

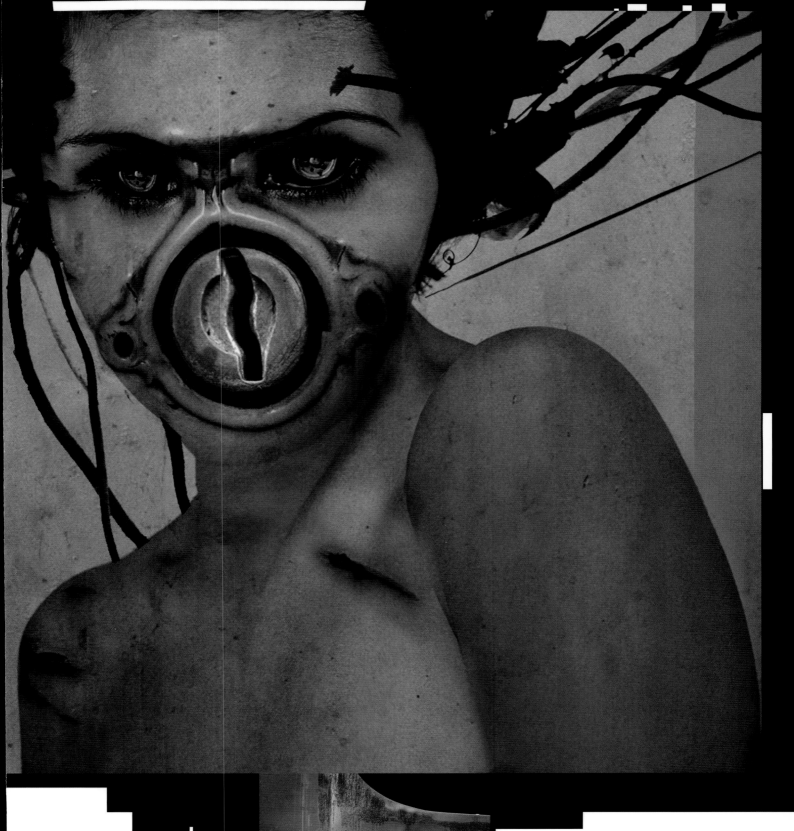

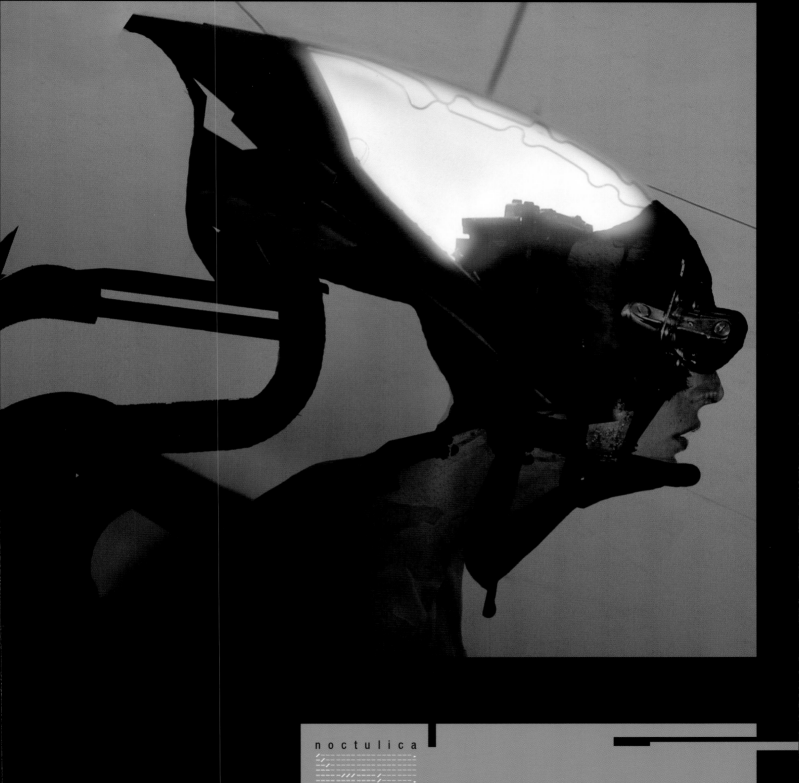

noctulica

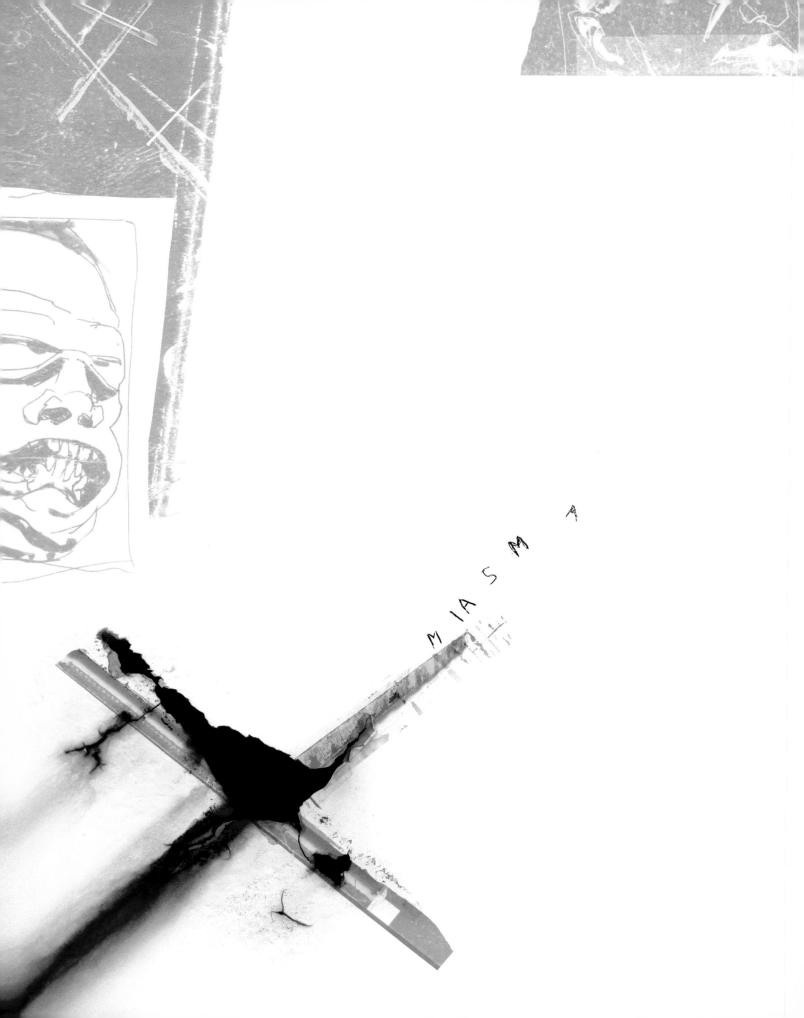

MIASMA

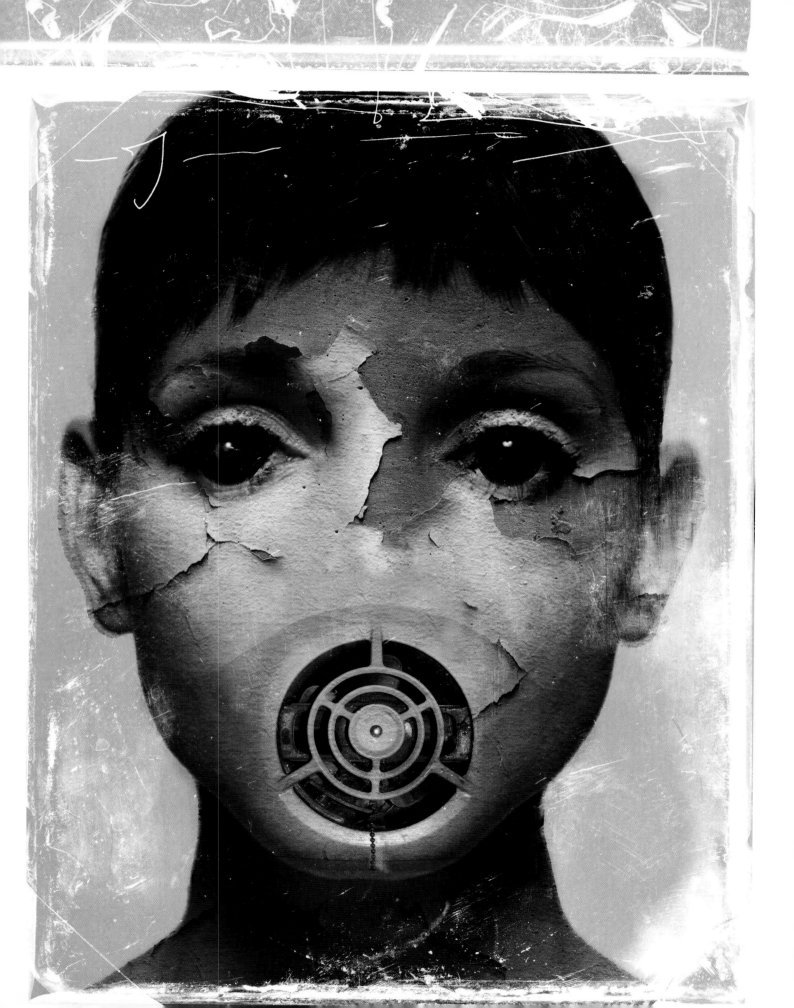

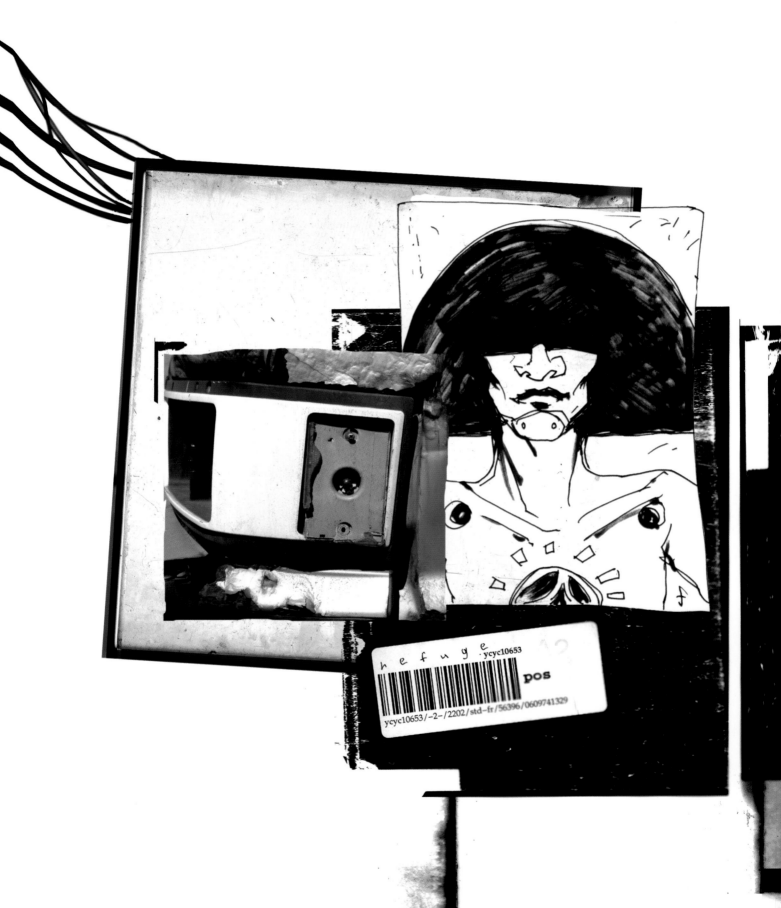

hefuge .ycyc10653

pos

ycyc10653/-2-/2202/std-fr/56396/0609741329

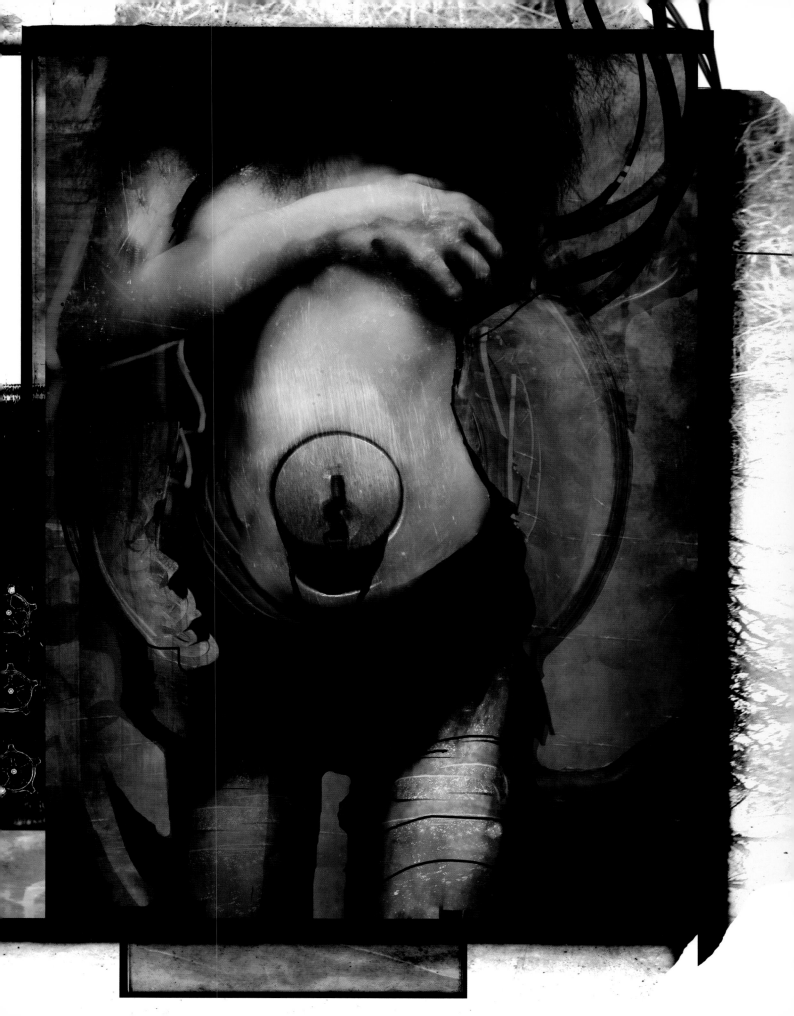

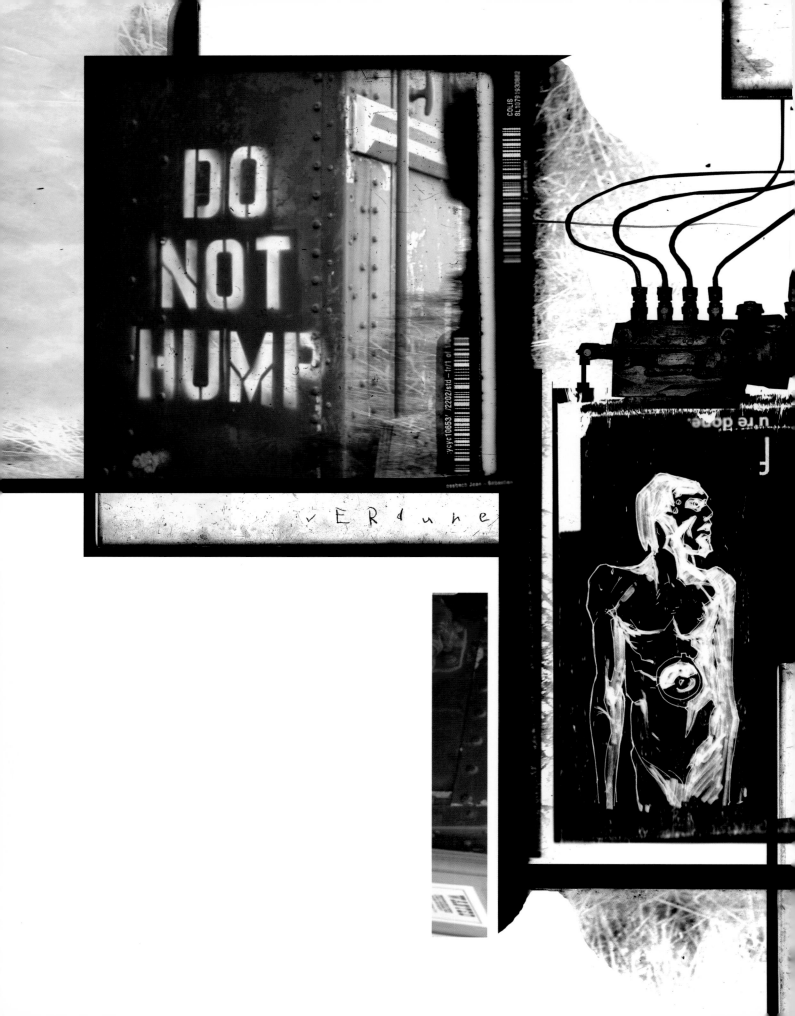

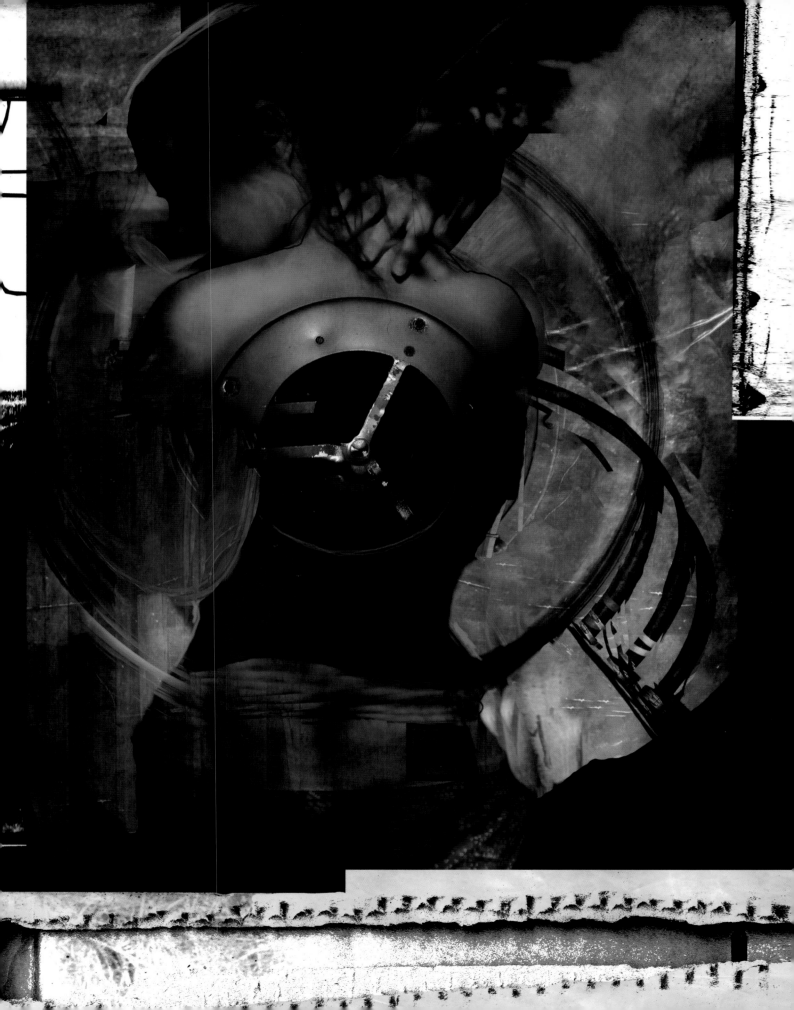

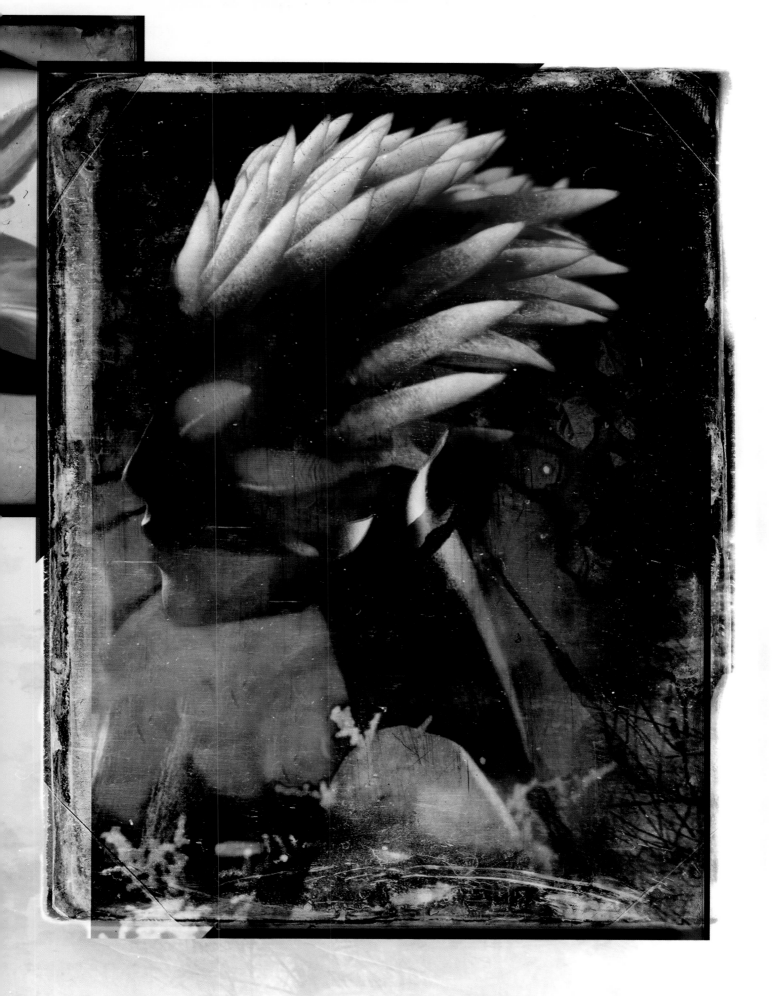

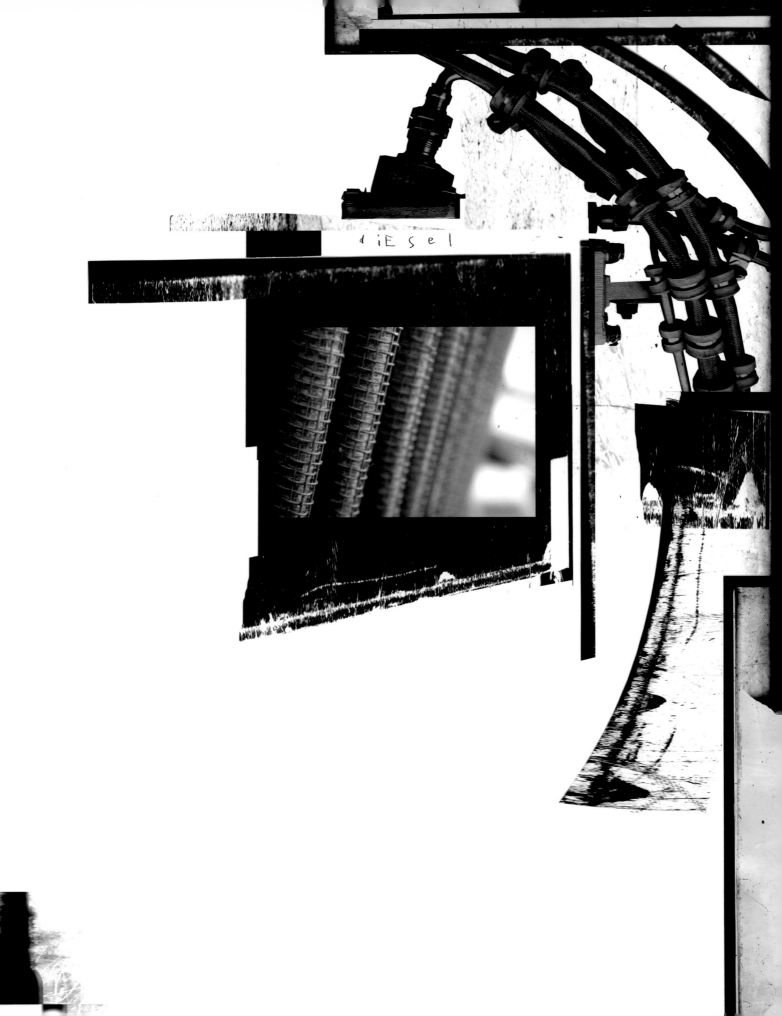

diEsel

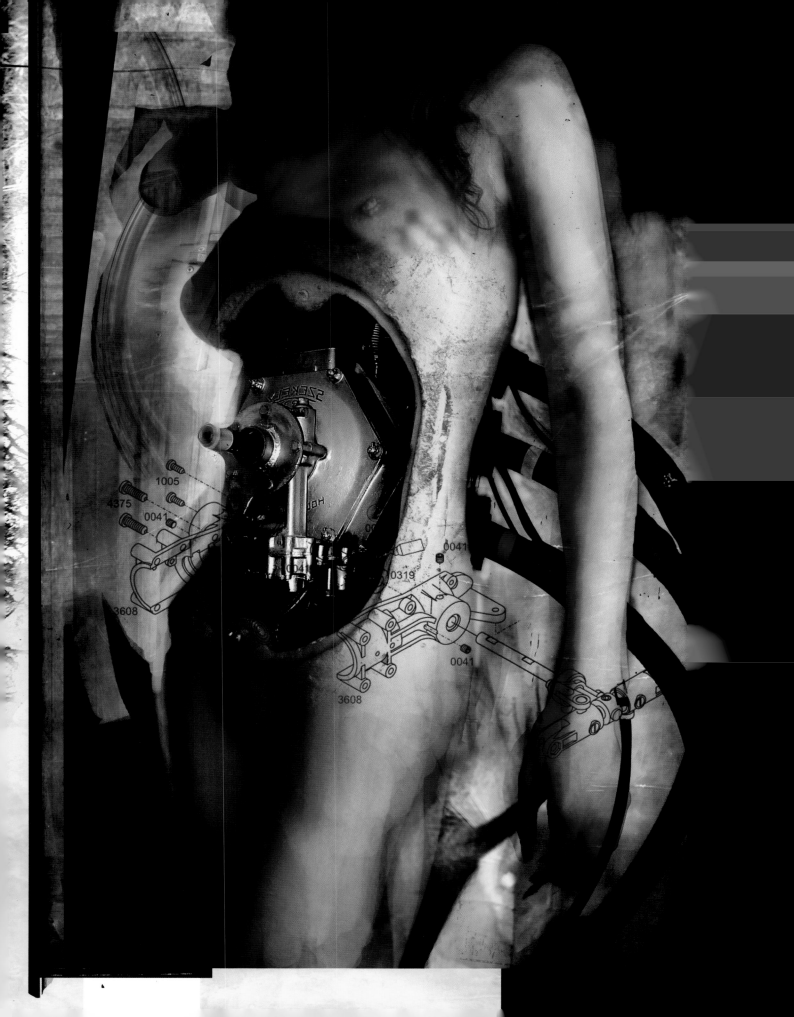

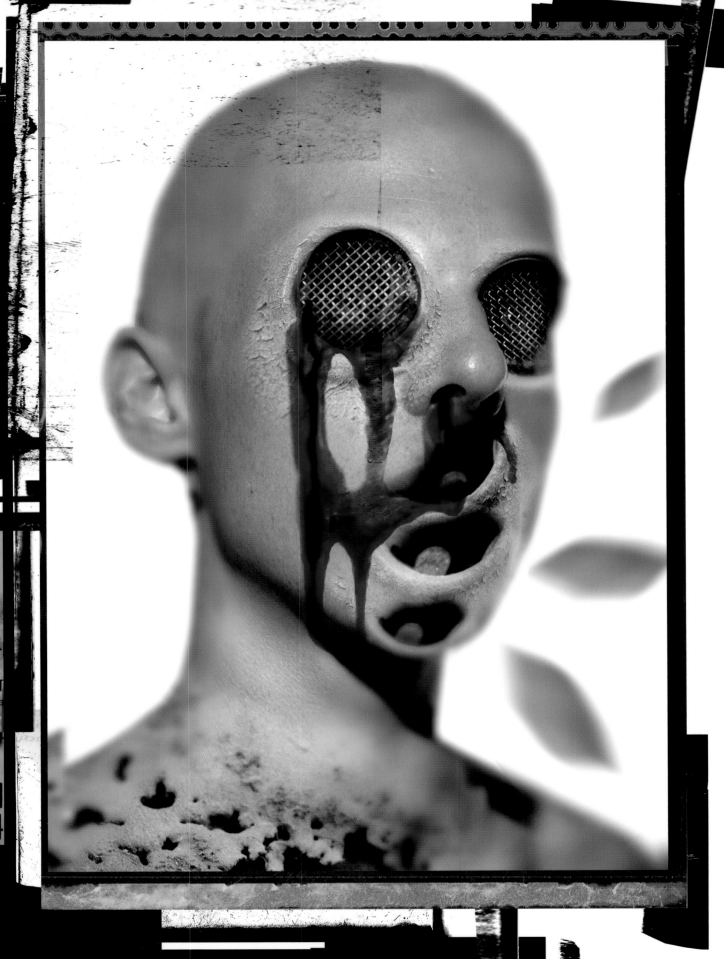

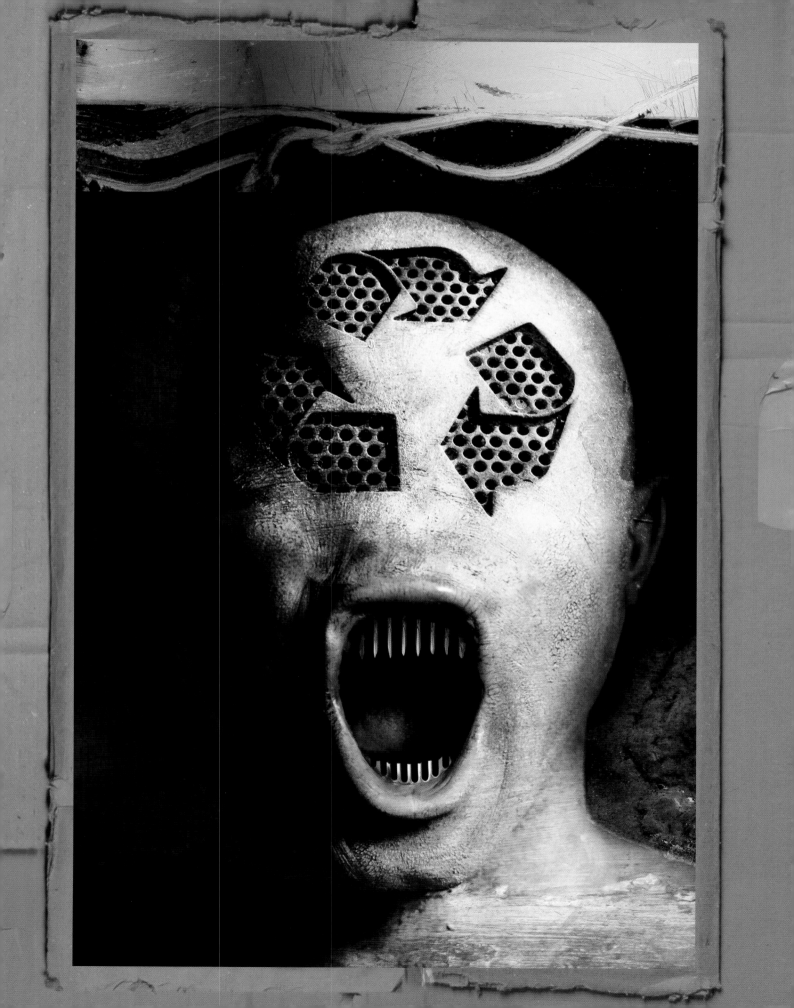

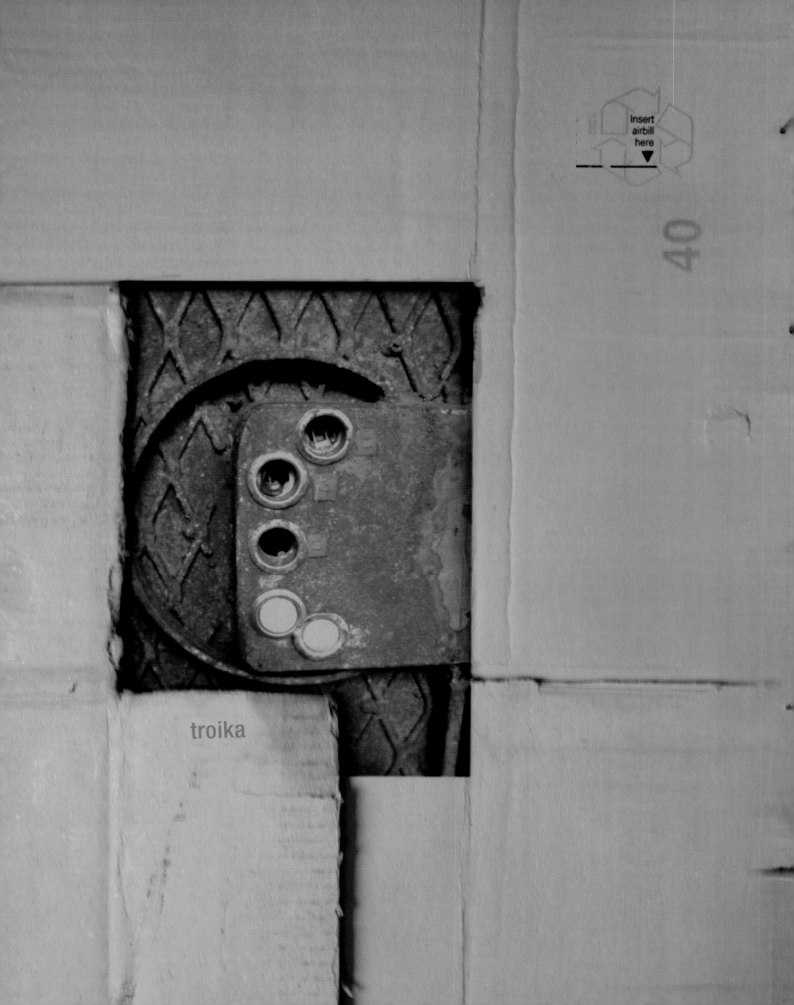

troika

lacuna

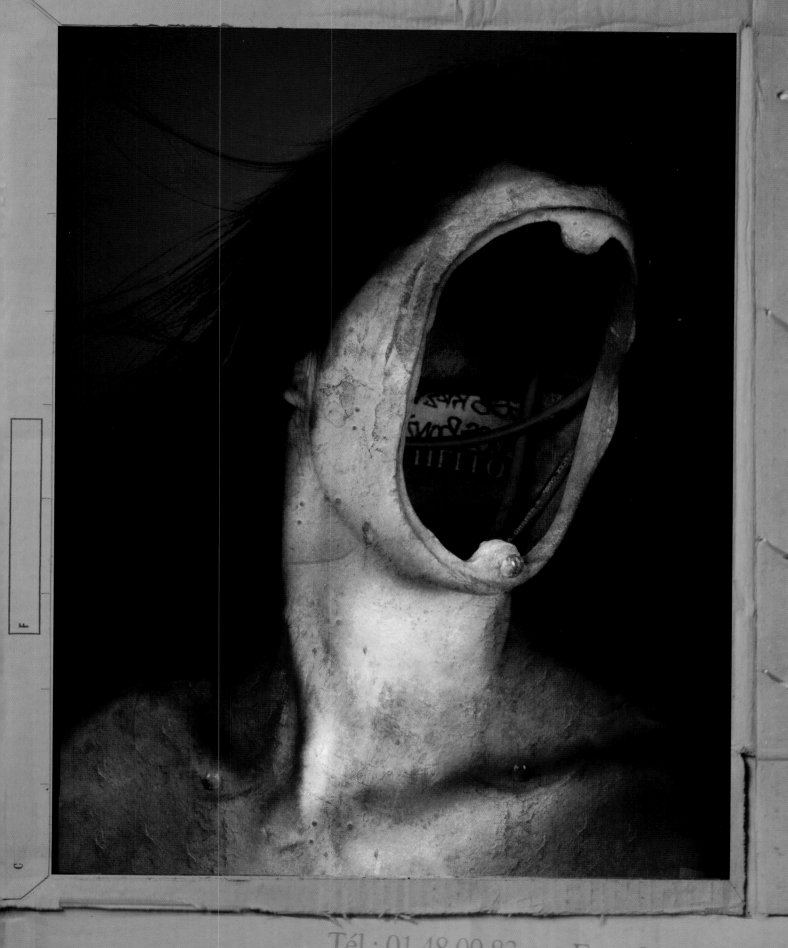

electro-noir

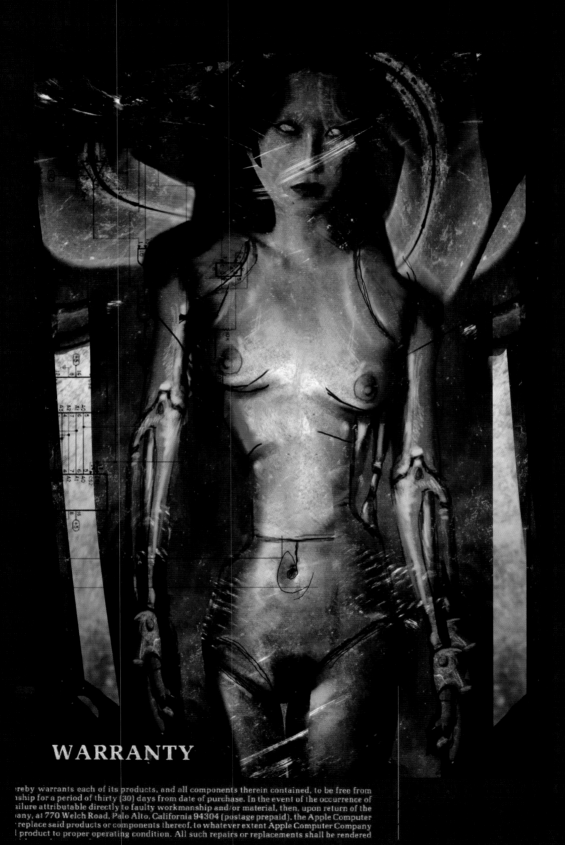

WARRANTY

...reby warrants each of its products, and all components therein contained, to be free from
...nship for a period of thirty (30) days from date of purchase. In the event of the occurrence of
...ailure attributable directly to faulty workmanship and/or material, then, upon return of the
...any, at 770 Welch Road, Palo Alto, California 94304 (postage prepaid), the Apple Computer
...replace said products or components thereof, to whatever extent Apple Computer Company
...l product to proper operating condition. All such repairs or replacements shall be rendered

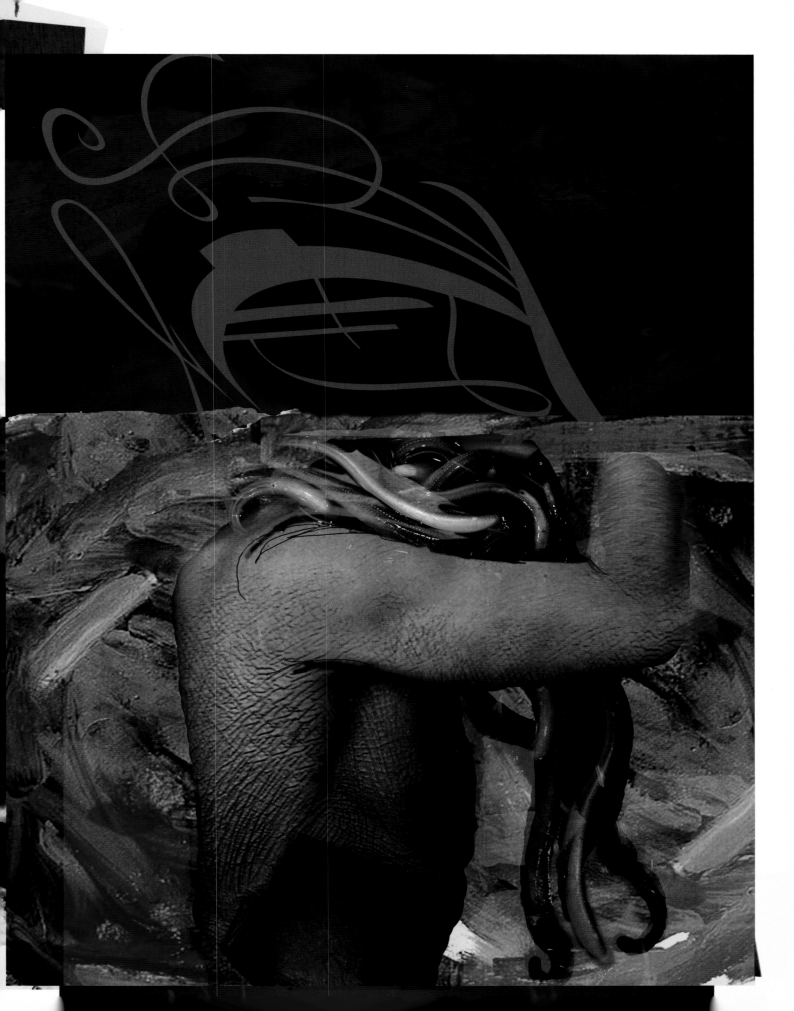

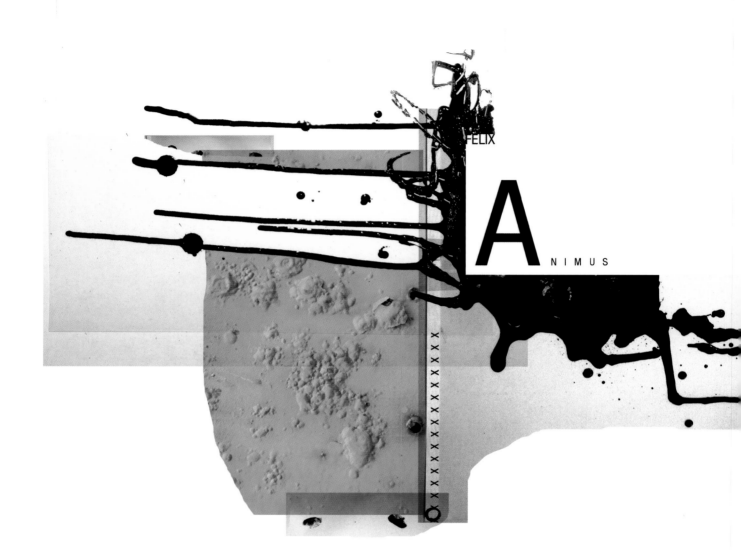

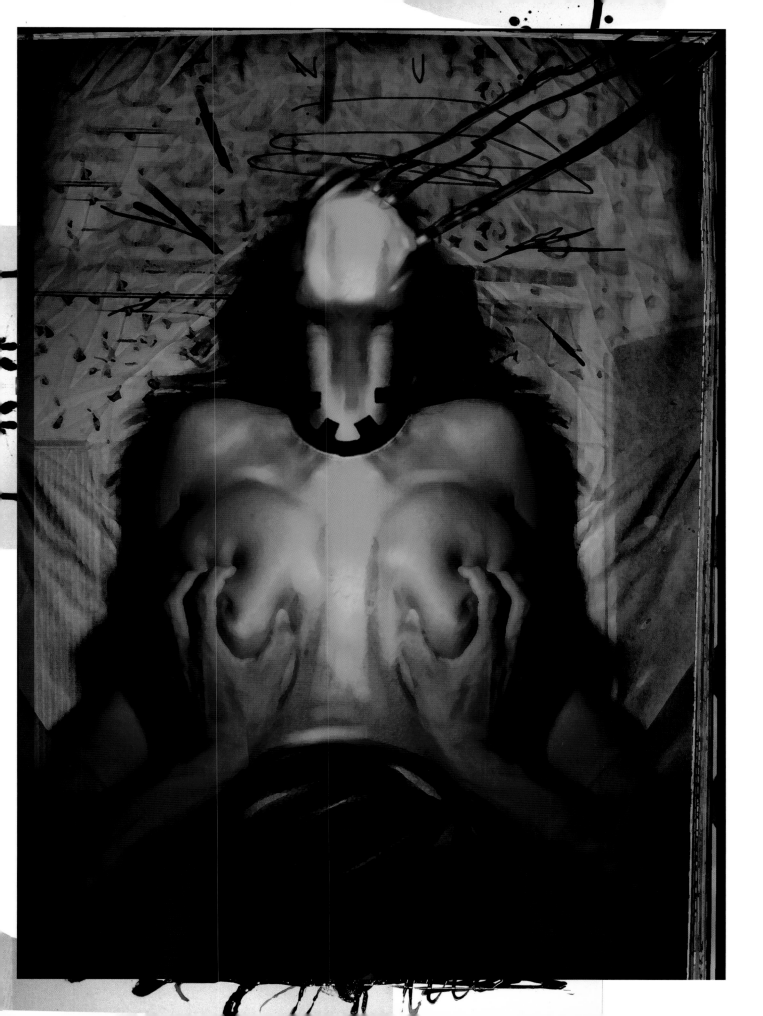

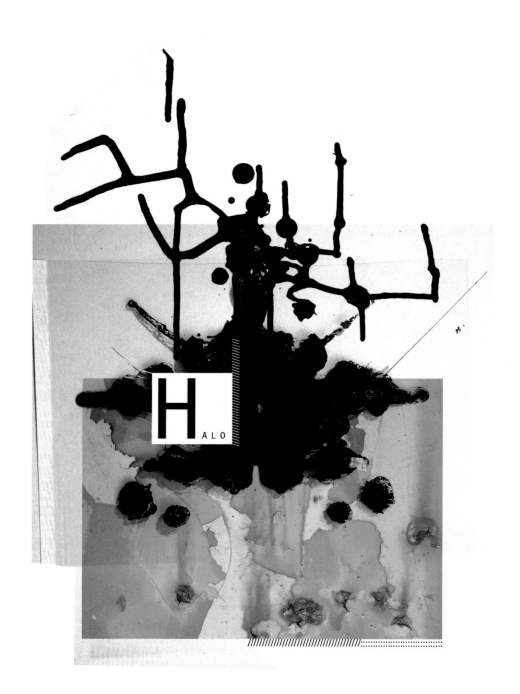

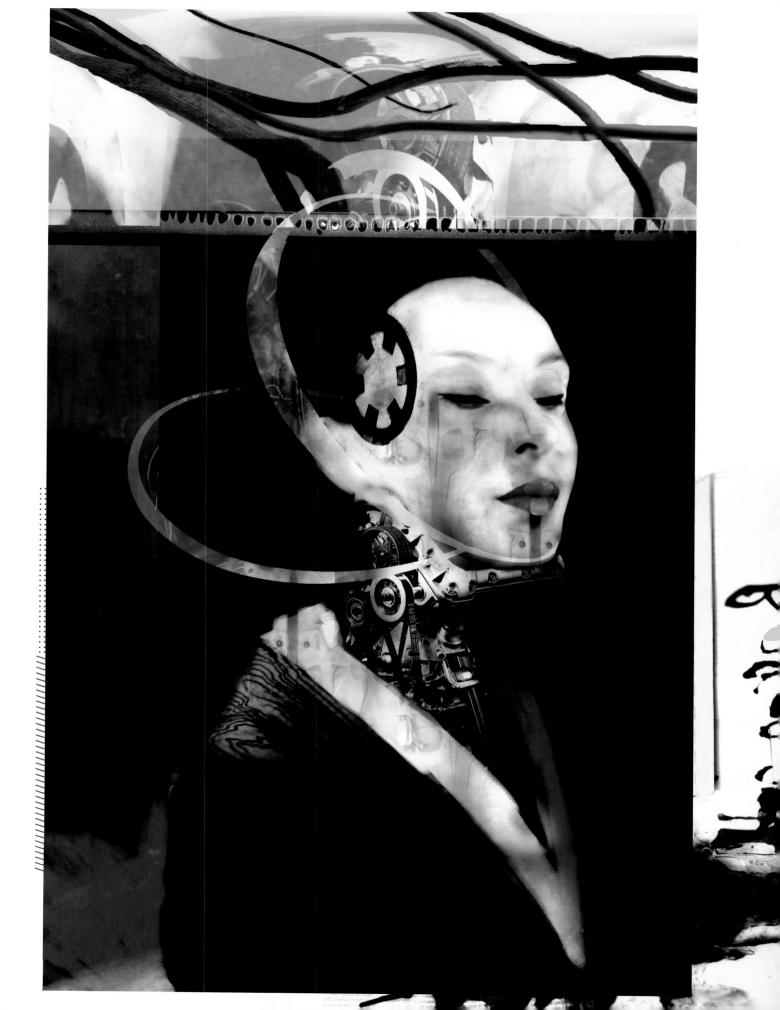

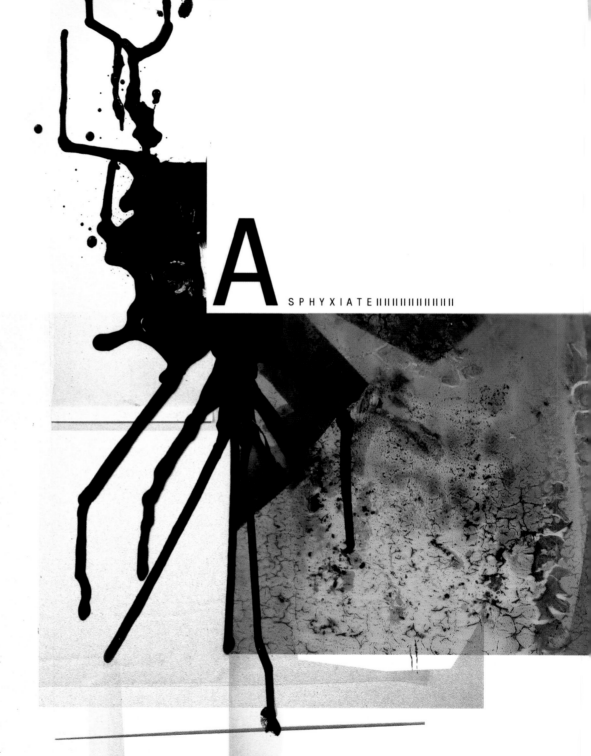

A SPHYXIATE ||||||||||||||||

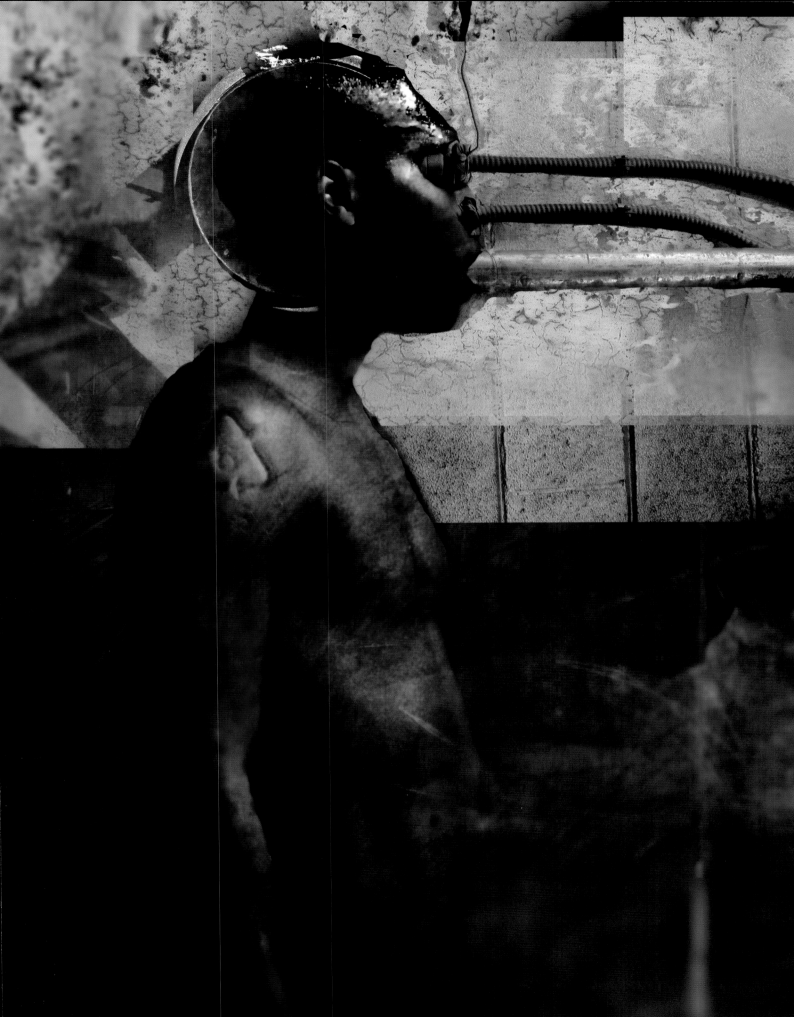

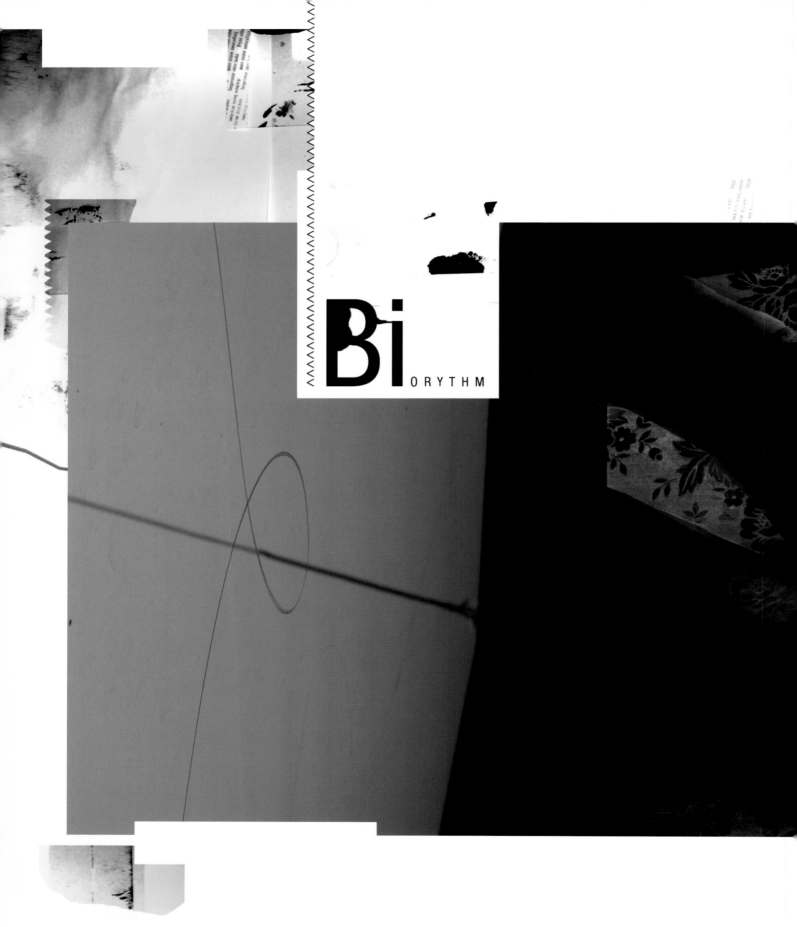

BiORYTHM

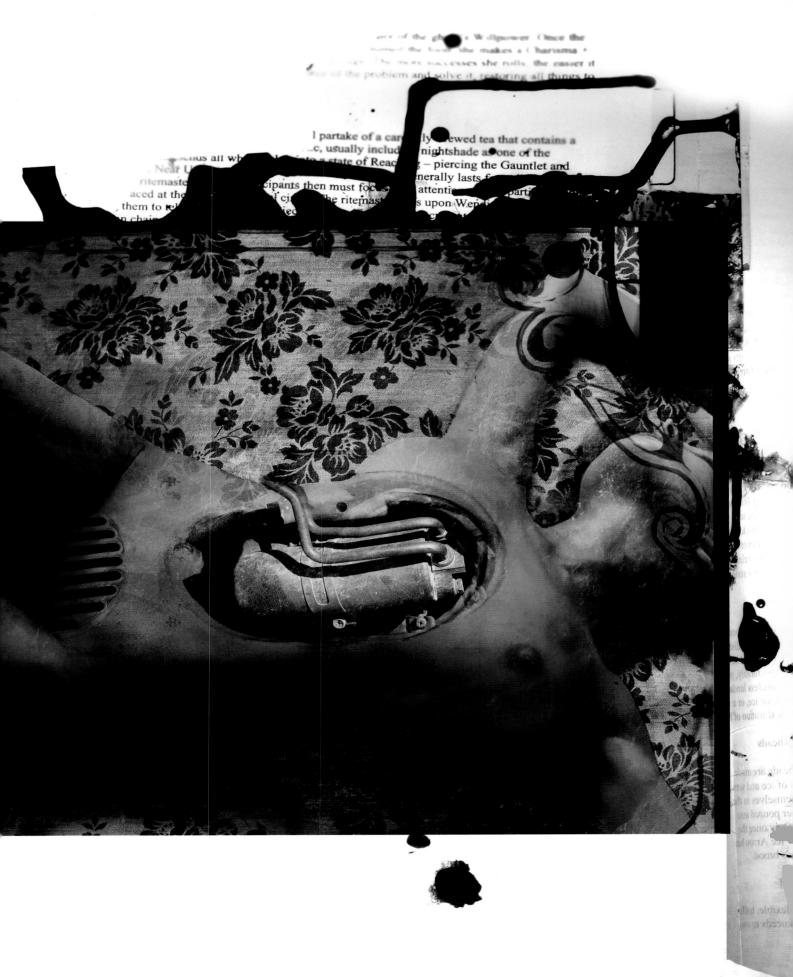

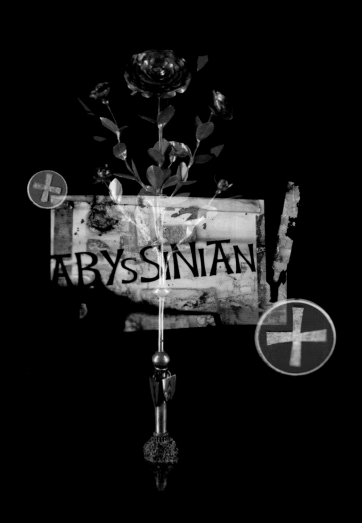

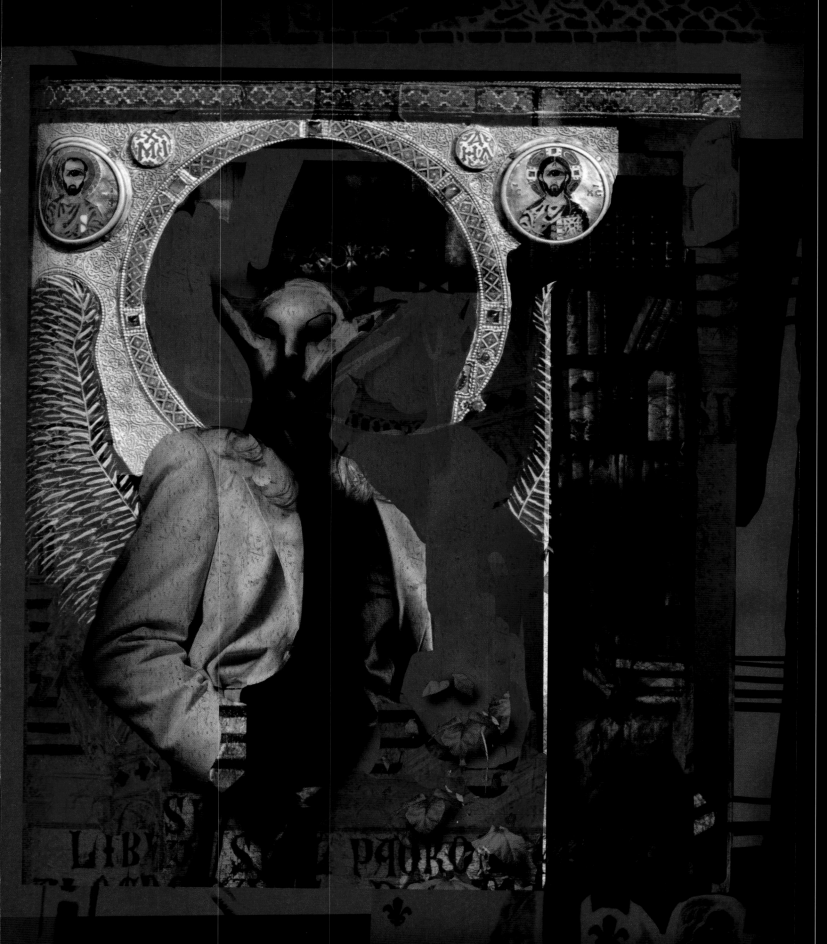

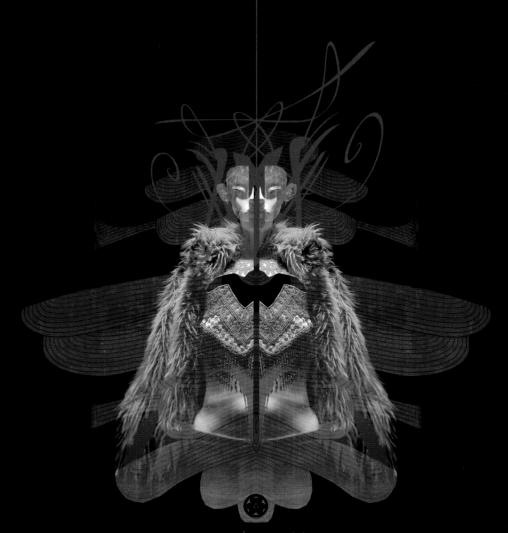

marionette

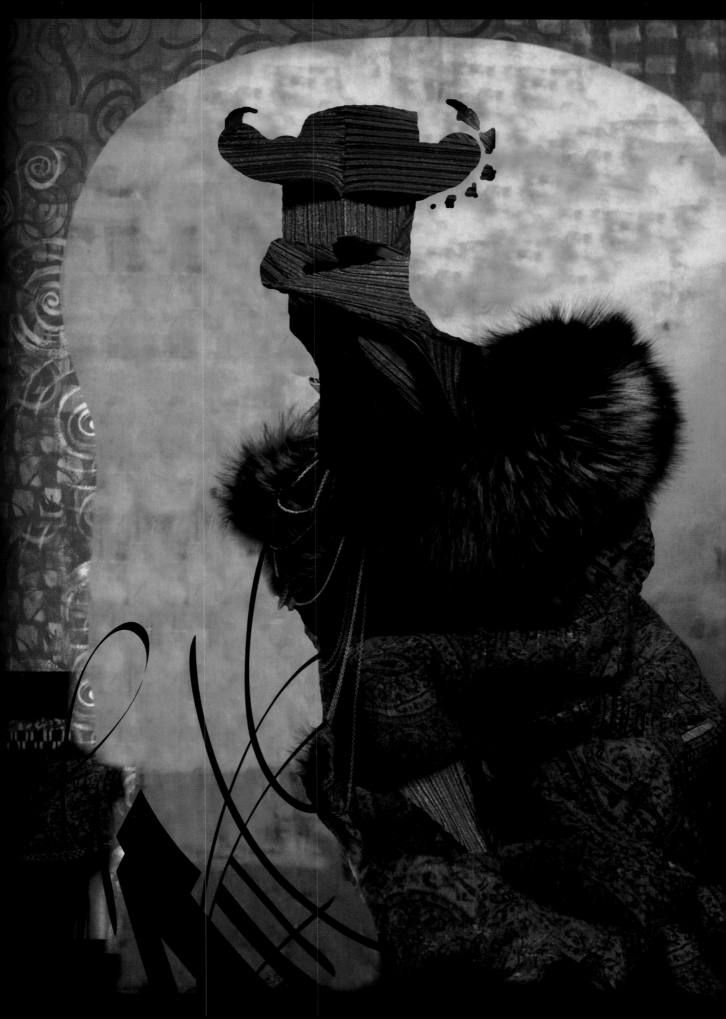

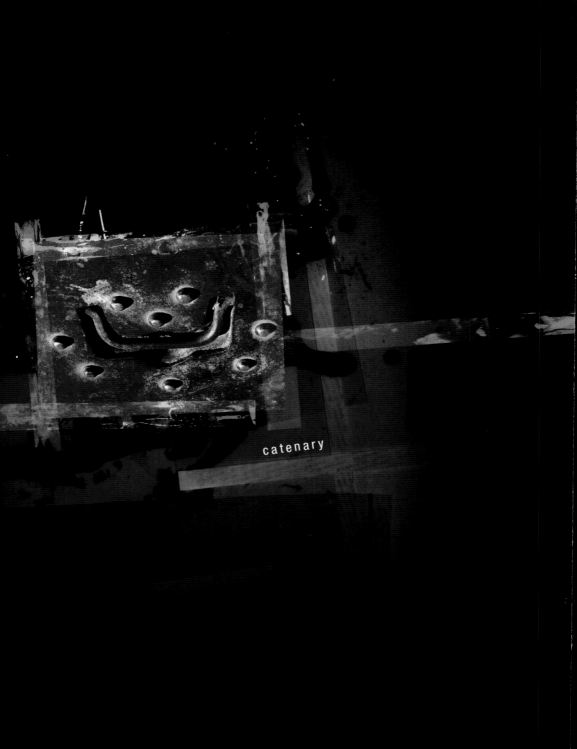

catenary

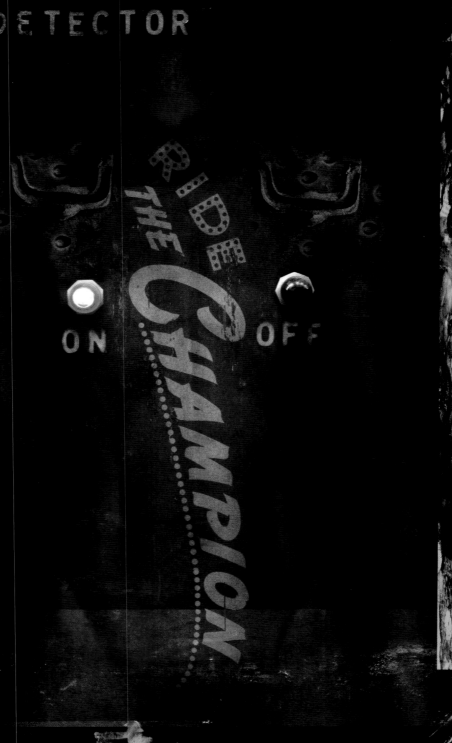

dahlia

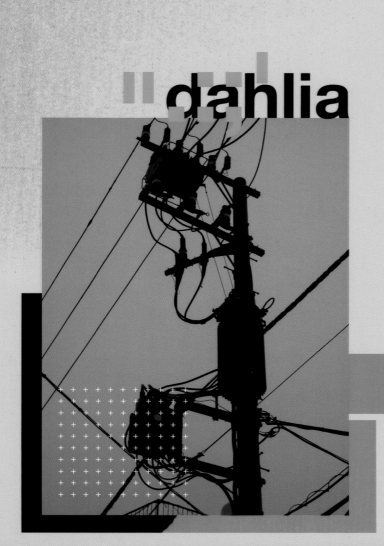

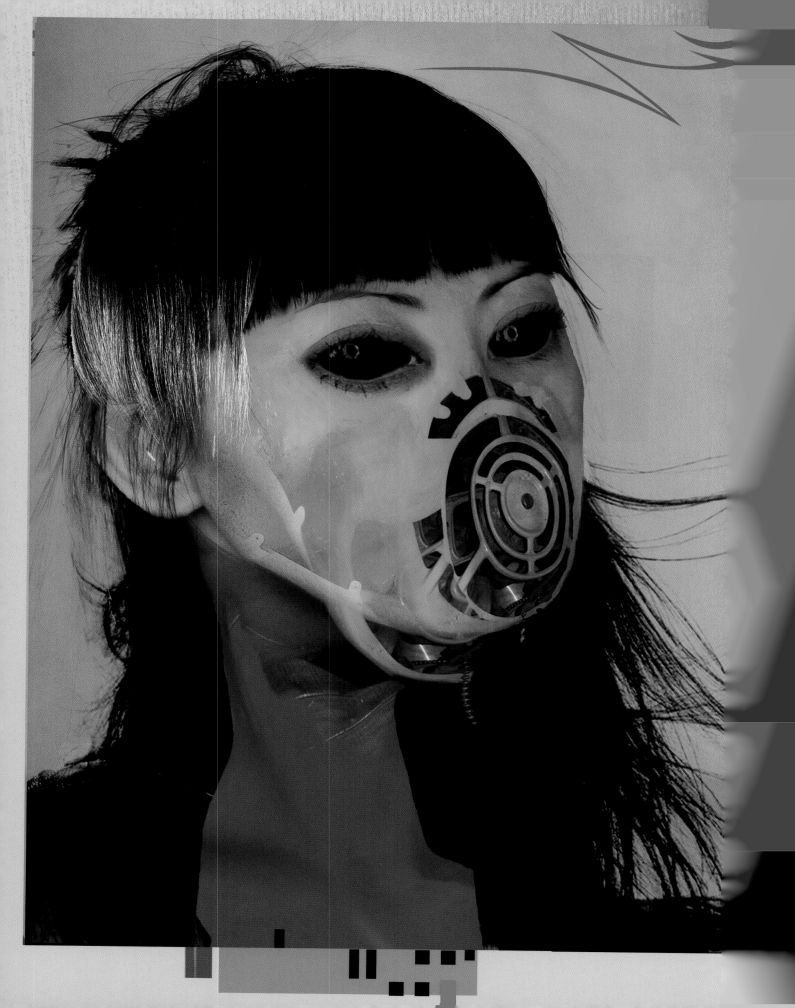

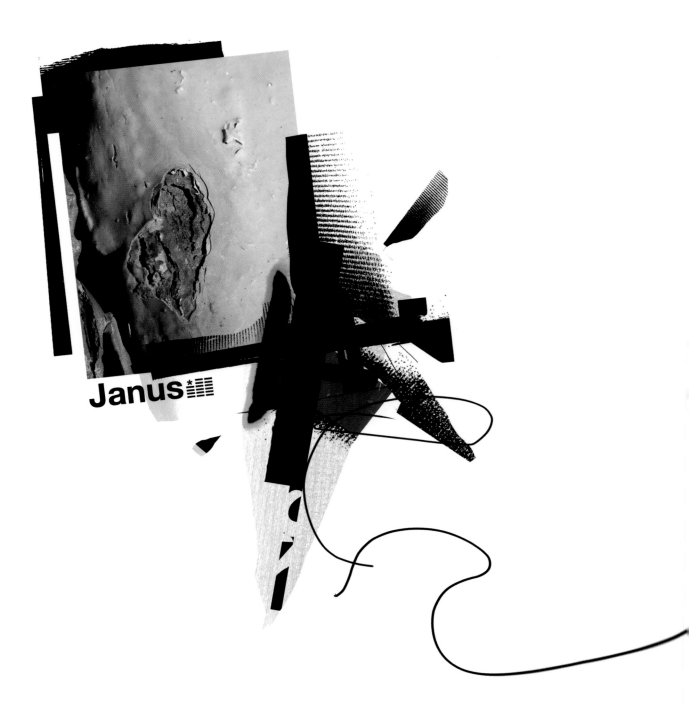

Janus*▦

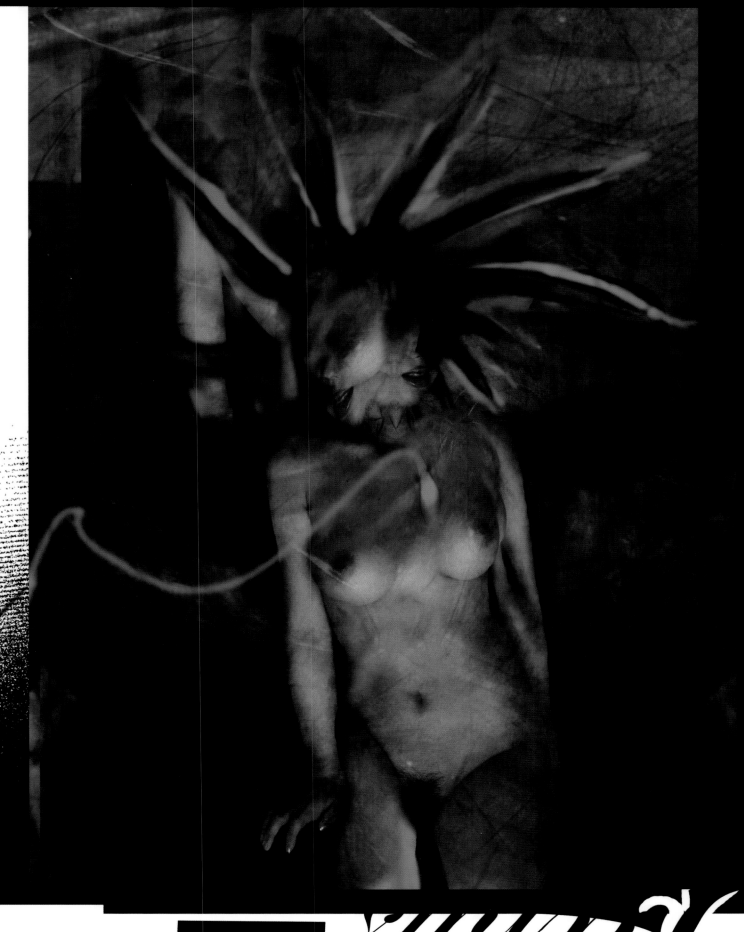

IINeuro

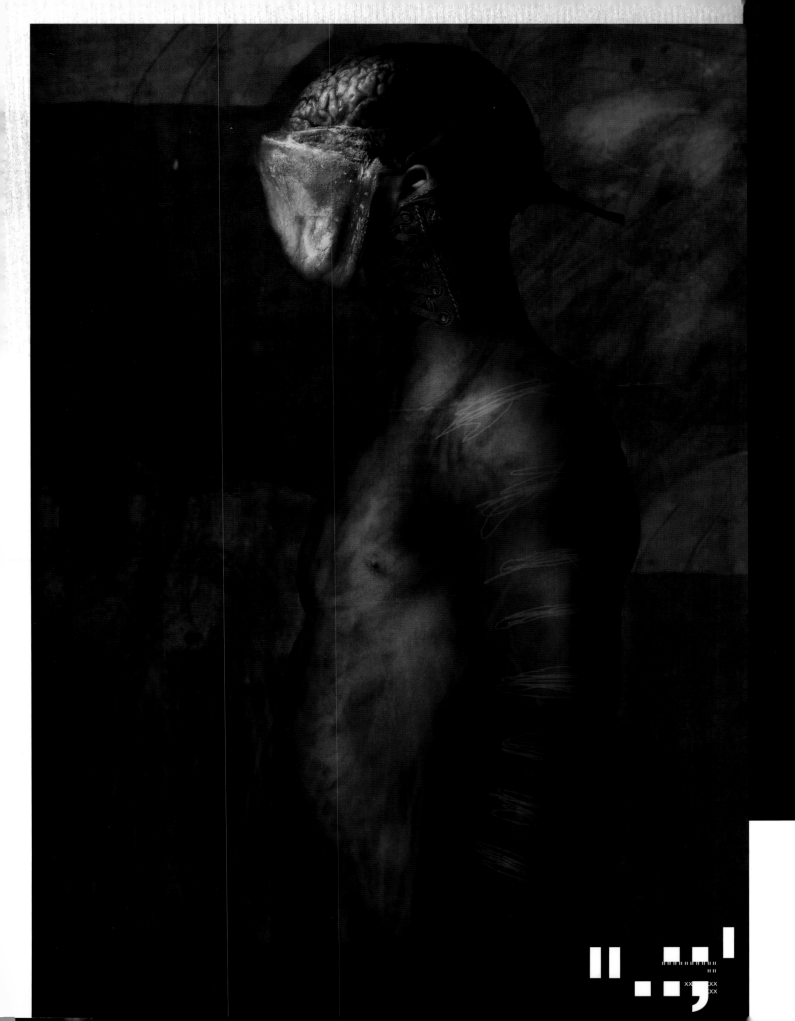

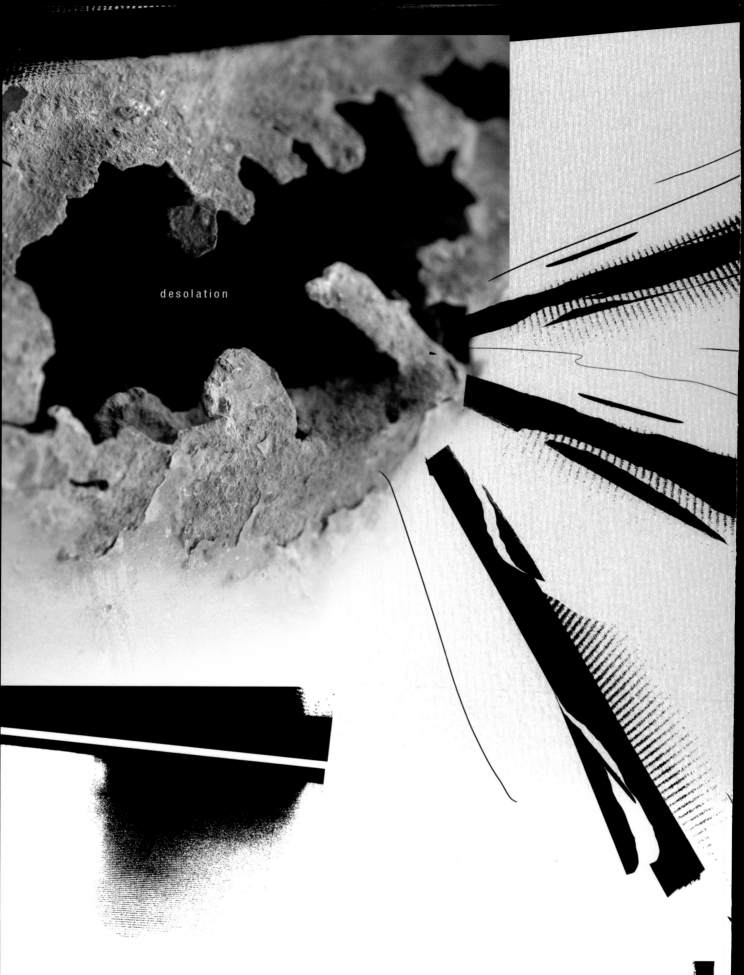

desolation

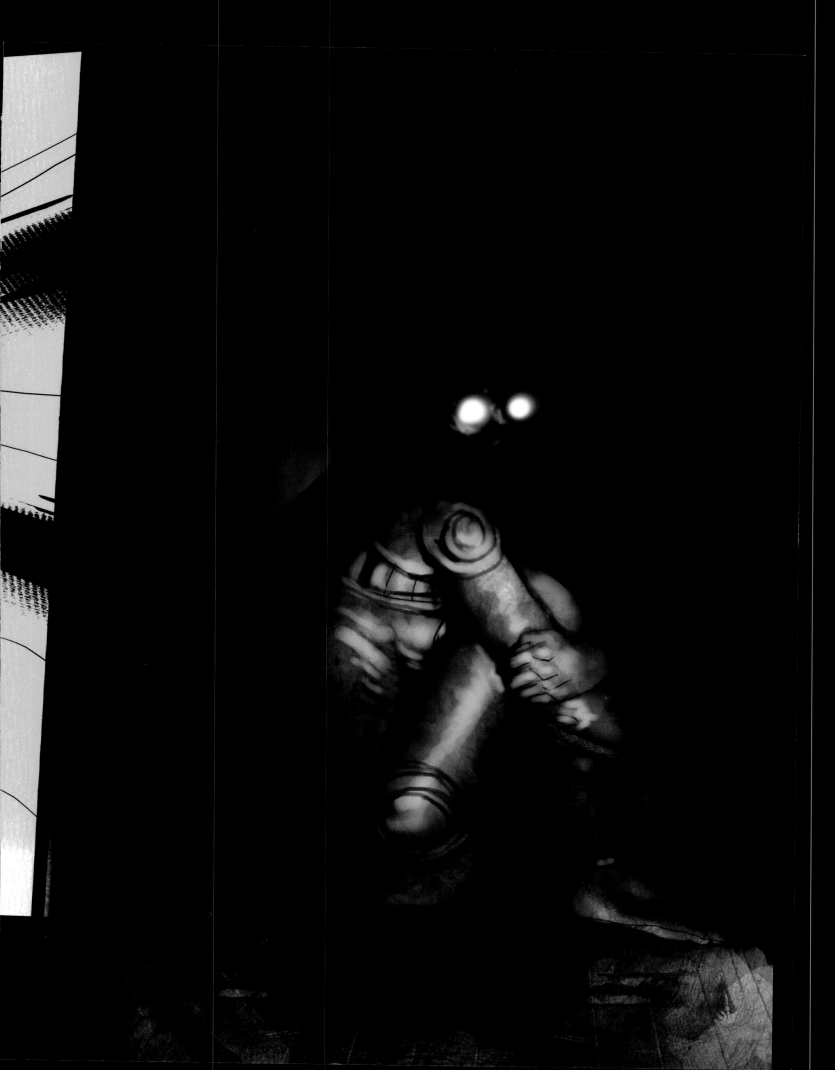

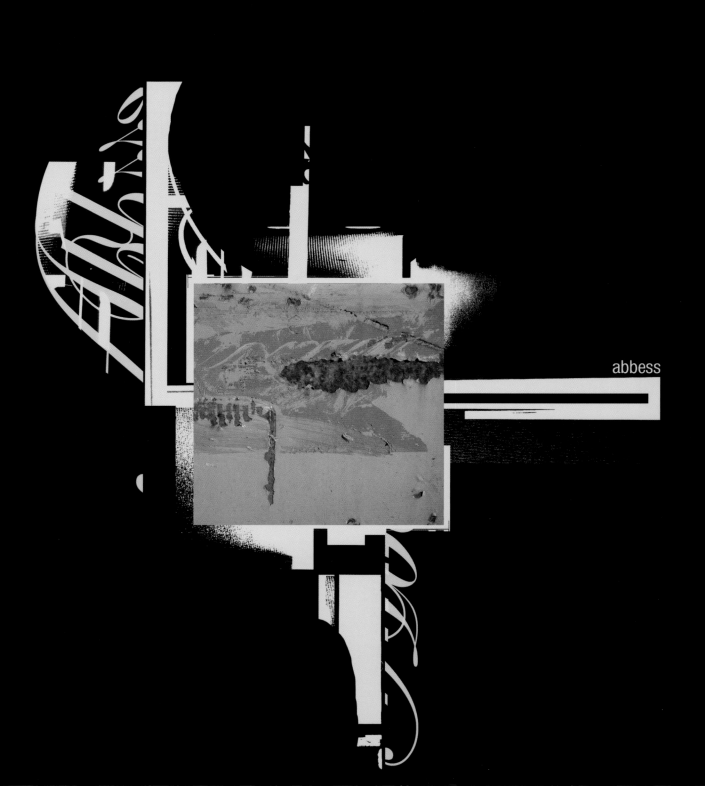

abbess

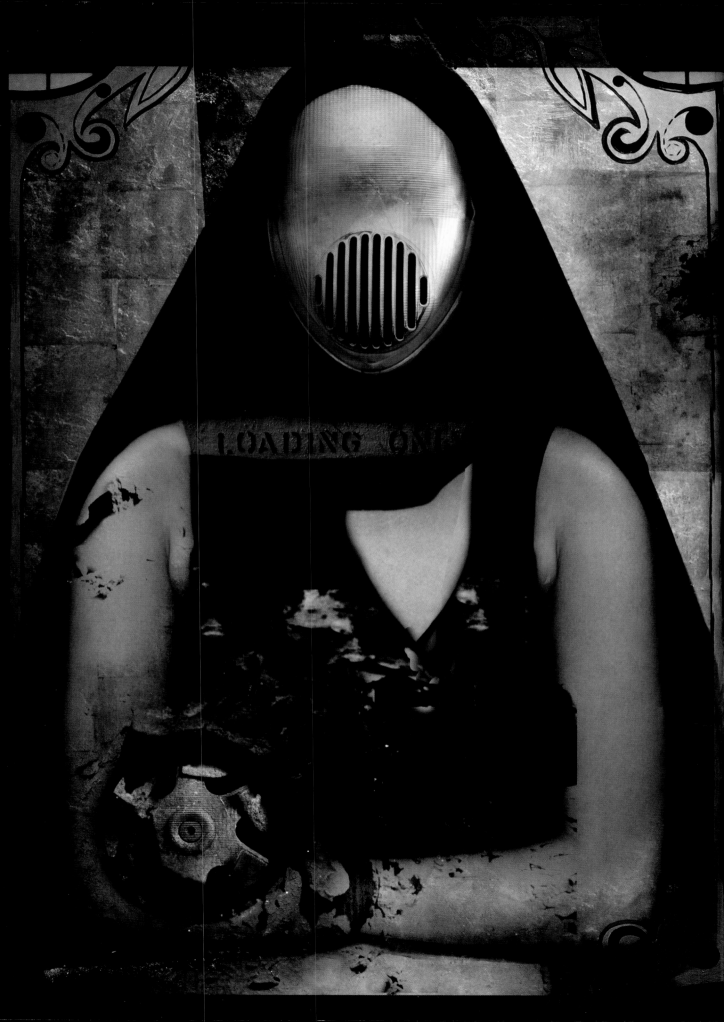

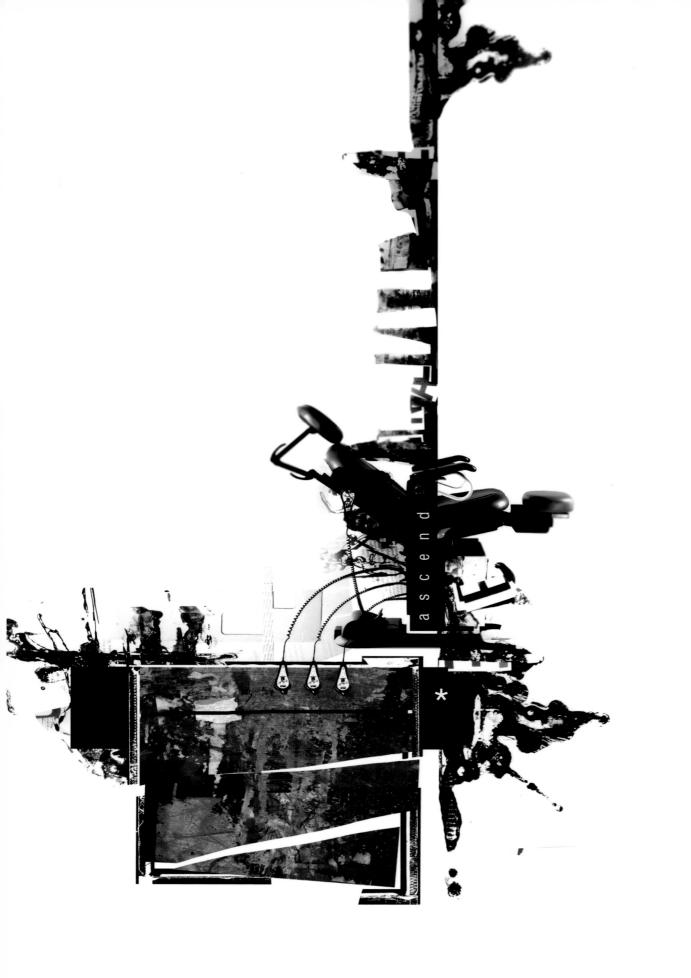

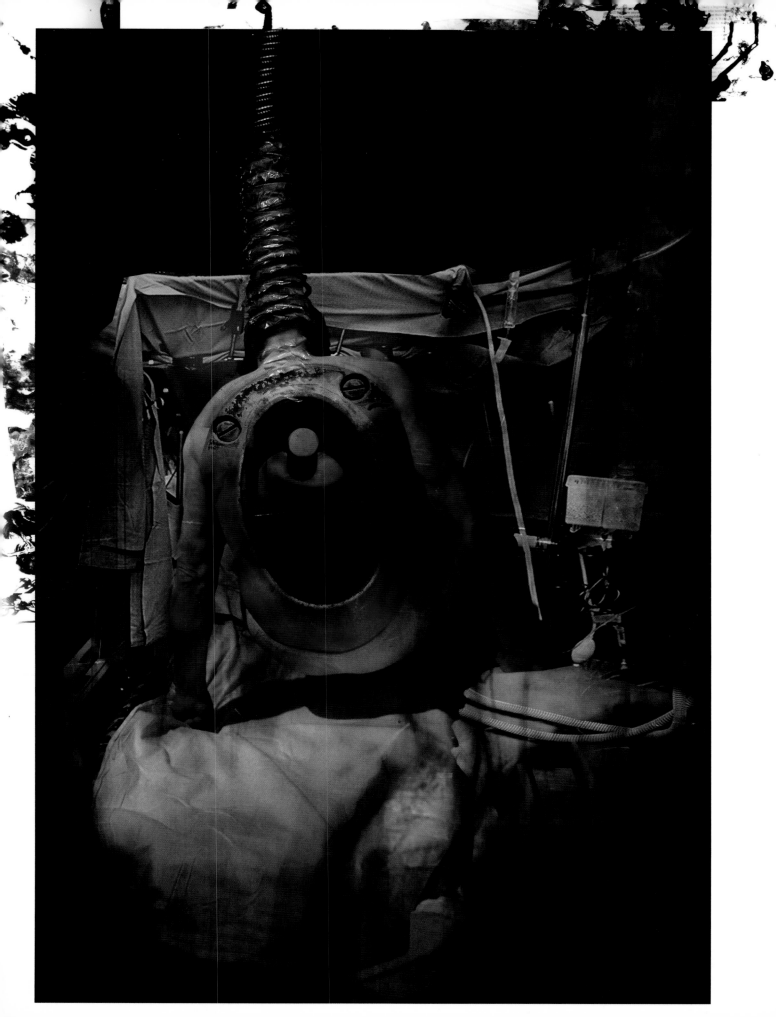

Acolyte

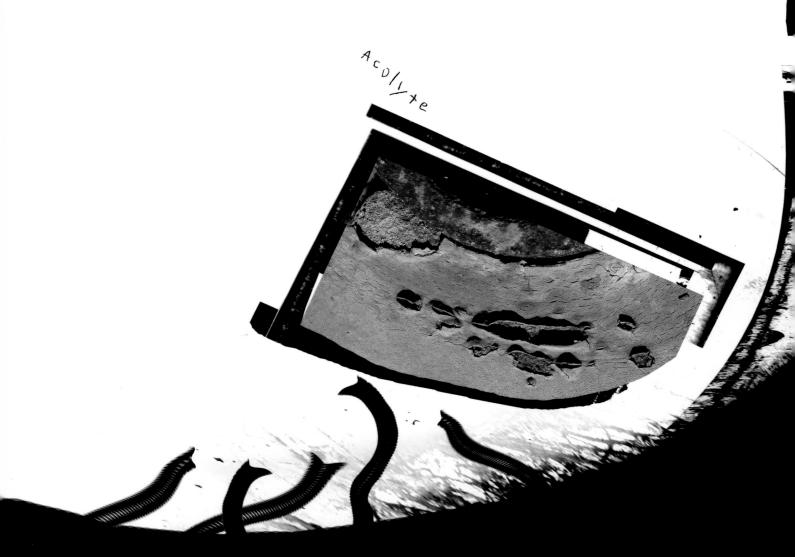

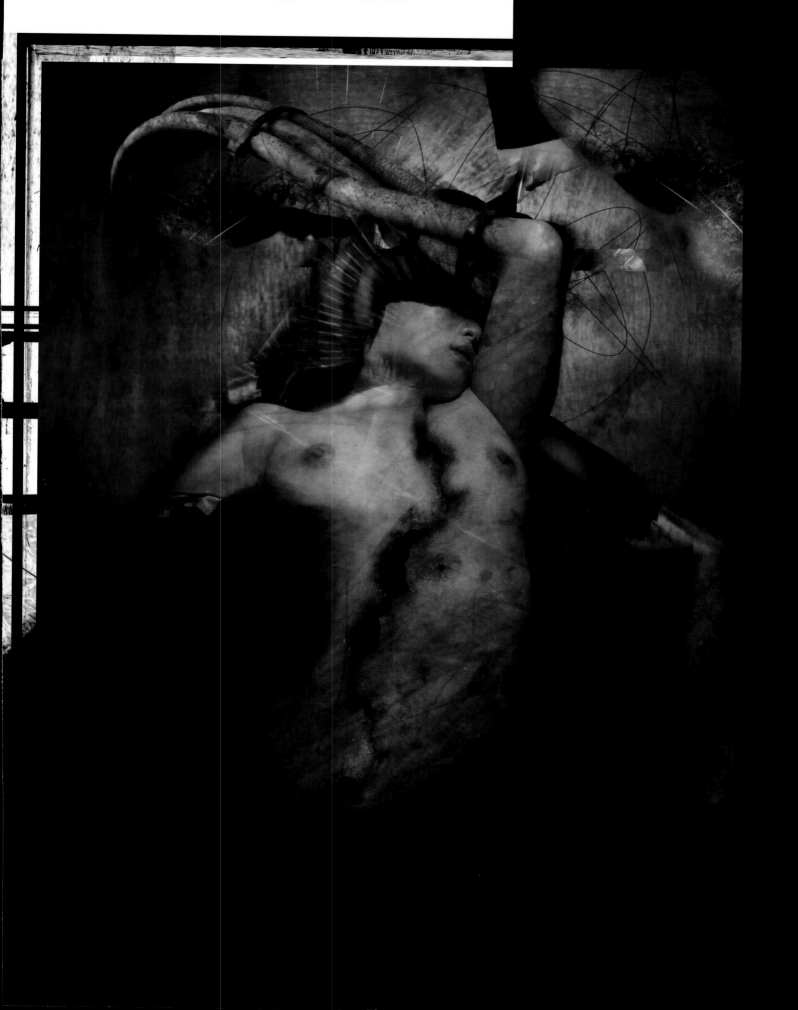

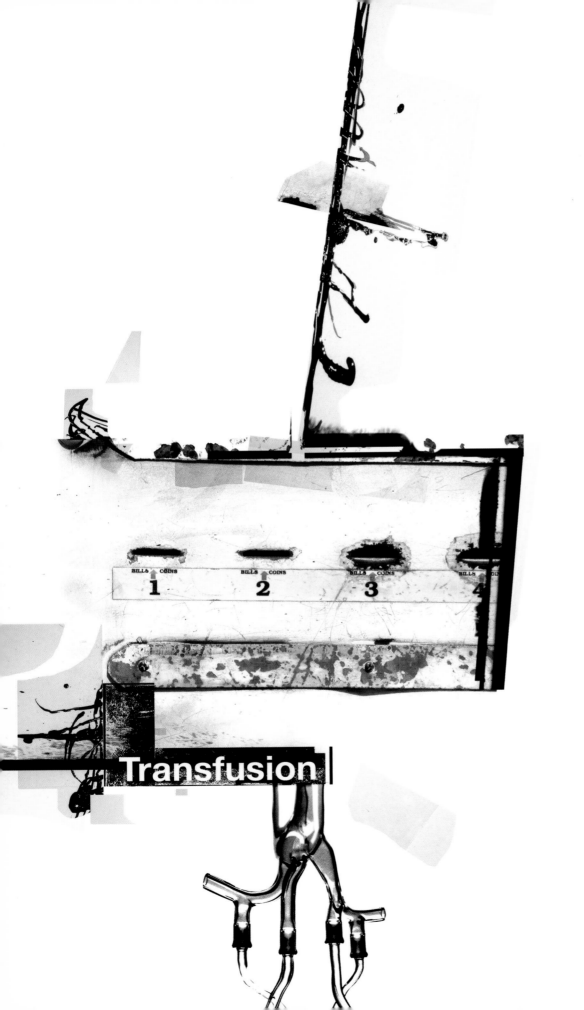

BILLS COINS 1 BILLS COINS 2 BILLS COINS 3 BILLS COINS 4

Transfusion

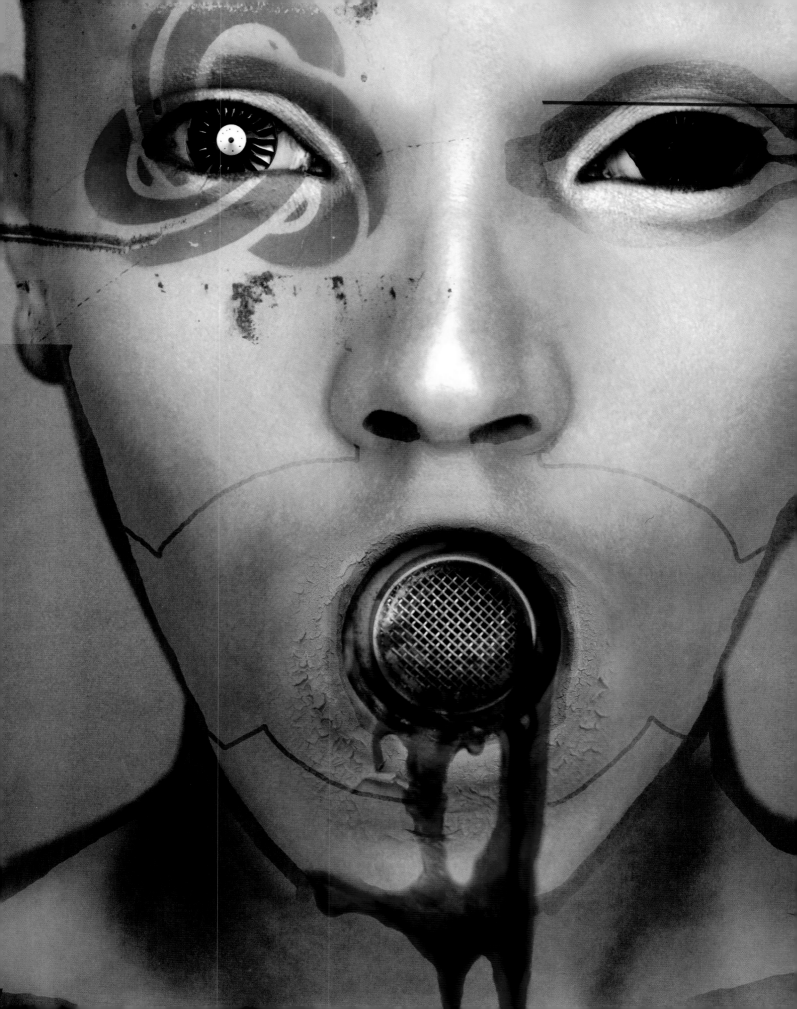

When Jason Felix came to me asking if we could join our forces on this book you are holding in your hands, I felt so honored. I have known his art from the time I was a vampire RPG enthusiast and he was already illustrating the books I was reading. Jason and I have a lot in common: We are the same age, are both self-taught, and we share the same love for collage and graphic design. We developed similar techniques, even though we live at opposite sides of the globe.

From our very first discussions, the idea behind *Salvaged* was to meld Art and Design just like Dave McKean did on his seminal *Dust Covers*, which was a true inspiration for both of us. We managed the melding process so well that you may now have problems seeing who did what in this book! I'll try to explain my part of the job here.

When I first imagined my role on this project I thought that I would create the most beautiful jewel case for Jason's art. I think I went a little farther. Something strong happened in the beginning of the process, when he sent me his hi-res images. I plunged deep into his art, to the point that I could see all of his gestures, all his decisions, I went into his colors…and it was pure bliss!

Soon I was able to understand that Jason's art is not about beautiful women and mechanical scars. These elements do exist in every piece he creates but they are only pretexts to something more powerful, something that talks to everyone. Jason's art is pure abstraction. It goes to the root of it all. When you look at clouds, you see shapes that recall to you a sheep or a deer. This is the trick: Jason takes pictures of rusted textures and then he sees things, just like a child does. Back in front of his computer, this juvenile energy goes straight from his mind to his fingers, and he cuts and pastes and draws until he gets the result he wants. And the result comes quickly, after a few moves and confident decisions, because the man is gifted. Few people are able to create such elegant shapes, such strong compositions and gorgeous color schemes.

Understanding this process was mind-blowing, and soon I tried to emulate his technique. Basically, the game was to continue the art where he stopped. I say "game" because it definitely wasn't work. Each piece sent me a huge load of information that I simply had to stick back on the page. On most pages his pieces are at the right and I made an introductory design on the left. Jason gave me full freedom and he rarely had anything to complain about. For that, I thank him a thousand times.

He often told me that he was happy to complement his art with such inventive designs. The reality is that I wouldn't have been able to do it without being fed by his powerful images.

From the very beginning I knew I had to do this book with Jason. My way of thinking about art has changed drastically since then. I sincerely hope that you will travel as far as I did during this profound mindtrip.
Merci pour la balade, Jason!

JS Rossbach
France

Jason Felix was born in 1973 and raised in Green Bay, Wisconsin. As long as he can remember, Felix has always been creating art. After graduating from high school, he began to study graphic design at a local university. He was extremely fortunate to meet Neil Gaiman and was forever altered after being introduced to the artistic visions of Jan Svankmeyer, the Brother Quay and Dave McKean. With sound advice from Gaiman, Felix set forth to discover "Who Is Jason Felix?" After two semesters, he dropped out of college and began his search.

A self-taught artist, Felix got his start at nineteen working for *White Wolf Games* illustrating blood-thirsty vampires and other demonic creatures of the night. With more than five years experience as a starving artist, Felix crafted a unique artistic style that was powerful, edgy and unrelenting. His work appeared in countless books including *Vampire: The Masquerade, Mage: The Ascension, Werewolf: The Apocalypse* and *Wraith: The Oblivion.*

Seeking a career change, Felix took a leap of faith and relocated to San Francisco with no job or a place to stay. Armed with two suitcases, essential art supplies, confidence and limited funds, he applied to numerous studios and faced numerous rejections. It took three long years of struggling to secure a job in the video game industry. Since then he has created concepts, illustrations, 3D models, 3D animations and cinematic direction for high-profile video game franchises such as *Prince of Persia, StarCraft and Hellgate.*

In recent years, Felix has become known for his digital art, which has appeared in *Spectrum, Expose* and most recently adorns the covers of the *Star Wars* series *Legacy of the Force.* In addition, his work inspires numerous projects from video games, toys, novels and scripts to short films and feature films.

Felix currently resides with his wife and two naughty cats in San Francisco. He is busy creating conceptual artwork for video games, working on personal projects, exhibiting at galleries and traveling internationally.

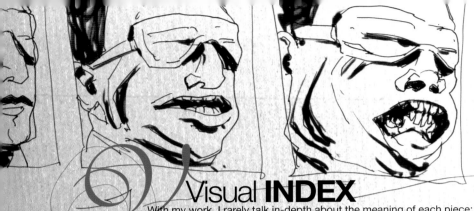

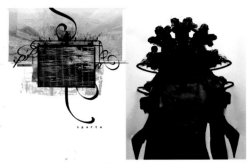

Sparta

Strangely enough, I drew inspiration from an old cast iron stove dating back to the early 1900s. *Sparta* is actually the name of the stove and eventually found its way on her chest. After compositing pieces of airplanes and random engine parts, this piece took on a new direction.

Visual **INDEX**

With my work, I rarely talk in-depth about the meaning of each piece; I am more interested in knowing and seeing what your reactions are. There is enough abstraction in the art that allows the eyes to see more than what is present. Everyone will have a unique experience, emotional response or interpretation. What could be meaningless to one might be full of depth to another. For *Salvaged*, I have written small captions for each piece to share some of my thoughts. By no means should my words persuade you; the intent is to give insight into my explorations.

—Jason Felix

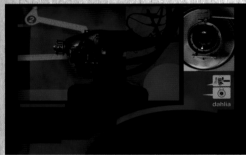

Dahlia

Industrial-sized dryers influenced part of *Dahlia*. The porthole is quite hypnotic to watch as the clothes flutter by. The name *Dahlia* is from a red flower found in Mexico, which gave a wonderful foundation for the color direction.

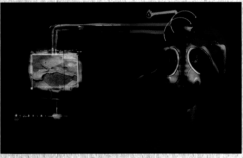

Obsolete 019

When I first started this series of images, they were originally titled *Obsolete*. The idea was to showcase a bunch of futuristic automatons that cooperatively fabricated their own society. Rather than naming each individual piece, they were assigned numbers that we regularly assign to all products such as Bar codes, ISBN numbers, or in our case, a social security number.

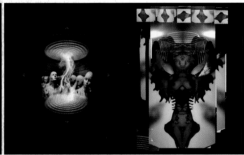

Cyberotica

While this particular piece started out as an innocent biomechanical humanoid, it ended turning into a subconscious sexual entity. Hidden throughout are lips and saliva that help to accentuate the name it adopted.

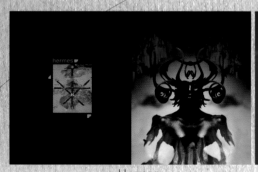

Hermes

Botanical gardens are great places to visit for inspiration and ideas. Roots, branches and budding flowers found their way into this piece. *Hermes*, from Greek Mythology, is the messenger from the gods to humans. There are also some subtle hints of Mother Nature within this piece.

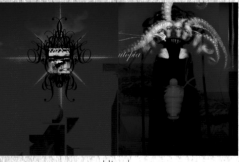

Utopia

Originally starting out as tentacles on a blank canvas, this piece was instinctively pulled in this direction by a song titled "Utopia." The music was hypnotic, soothing and sublimely beautiful.

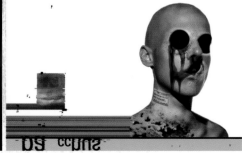

Bacchus

I am always curious to see how far I can push the human figure without crossing the fine line of being disturbing. A fusion of rusting metal, dry docks and human flesh... it happened to look like eroding skin. I've gotta admit, those floating eyeballs are frightful and the jam coming out of his mouth was delicious.

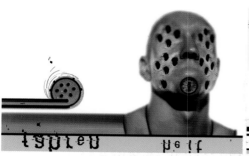

Fahrenheit

This piece just came together without much difficulty. It's too bad that you cannot see this *Fahrenheit* closer, but all the elements are strung together perfectly. Inspired by a furnace and a stove, *Fahrenheit* is remotely bizarre and very surreal.

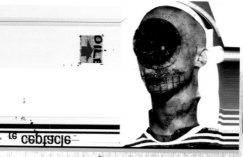

Receptacle

I ran across a trash can in downtown San Francisco that was specifically designed for smokers to put out their cigarettes and discard them in. After taking a picture of the intensely used container, I saw a face within. Compelled by that thought, *Receptacle* was born.

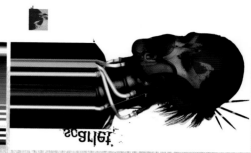

Scarlet

There is a navy base in Alameda that conducts tours of a massive ship called the *USS Hornet*. Also known as The Grey Ghost, it's a retired aircraft carrier that served in three wars and still host to an assortment of planes and engines. *Scarlet* was directly inspired by the ship's interiors.

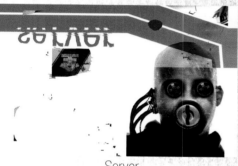

Server

While walking home, I photographed a garbage truck that had accidently tipped over and dispensed all its refuse onto the street. It was nasty, stinky and full of textures which I used to help create *Server*.

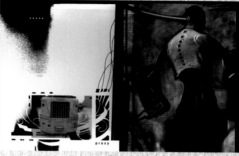

Proxy

Behind every building, vehicle or wall could be a bounty of ideas. I found a forklift sitting in an abandoned parking lot and immediately knew I had found a trove of ideas.

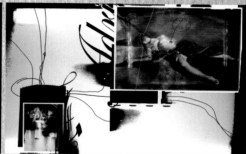

Adrift

Most dreams are meaningless, but the few that have meaning are important to remember.

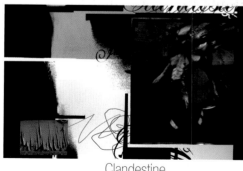

Clandestine

This piece started out as an experiment with textures and the enjoyment of manipulating them. I wanted to keep the image clean, but yet still have an edge of looseness. If you look hard enough you might see a hint of subversion or concealment that needs a second glance to find.

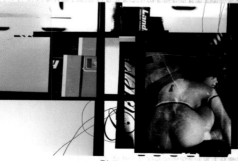

Cistern

Being a admirer of the Brothers Quay, there is an inherent fascination with antique ceramic dolls and mannequins. This is one of many images I created depicting life-like dolls adorned with iconic symbols.

Foresight

Foresight reminds me of the first *Matrix* movie. People all over the world are close to living that exact reality of jacking in and living a utopian life in a virtual world of their choosing.

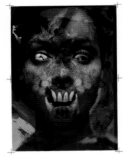

Rapture

Rapture looks like a gypsy woman dancing and performing. With this piece I tried to relax more with my paint strokes and focus more on the mood.

Hades

The future seems bleak to me at times and *Hades* amplifies that notion. This piece also pays tribute to all those well-crafted zombie movies. Mmm.... brains.

Ares

Ares is my depiction of Greek mythology's God of War. The raw and aggressive paint strokes were unexpected elements that did well in intensifying the grotesqueness. Her right eye was influenced by a heart valve that if animated would pulse with every breath she takes.

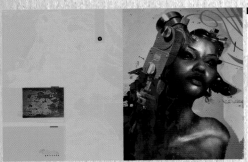
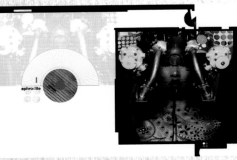

Golconda

Applying an absurd amount of heavy metal to the side of a female's head would seem rather unsightly, but somehow it works well. The name *Golconda* derives from a ruined city in South India. It was famous for its rich mines and diamond cutting.

Aphrodite

Japan is an amazing place to visit. The heritage and history of the *Geisha* is fascinating. The ornamentation, designs, costumes and beauty are an endless source of inspiration. Combining industrial elements with traditional designs resulted in the birth of *Aphrodite*.

Malefic

This ended up being a variation of *Scarlet*. The color changes and the additional backdrop created a unique look that deserved its own spotlight.

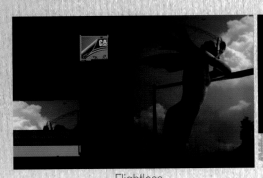
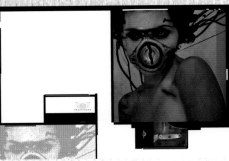

Flightless

A personal favorite and one that yearns to tell a story, this image is all about a female android unit that has lost her ability to fly. Seeking nostalgia, she spends endless hours sitting at the airport watching planes taking off and landing, wishing she could fly again.

Chartreuse

Chartreuse was created from the same stove used for *Sparta*. The stove had a bold appearance, but yet smooth sexy lines. The keyhole mouth gave *Chartreuse* a distinctive fetish appearance.

Noctulica

Noctulica lead to numerous ideas about designing self-luminous androids. The headdress infused traditional tribal art from Africa with technological parts of the airplane.

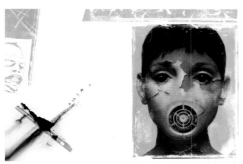

Miasma

A ceiling fan and peeling paint found in a moldy hotel bathroom lead to the creation of *Miasma*. Taking pictures of everything made the bathroom seem not so infested, rather full of life.

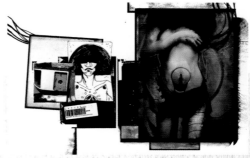

Refuge

The symbolic keyhole icon and the word *Refuge* may represent a place of protection, shelter, safety, haven or sanctuary. I also included a circular motion in the background that is subtle, but adds a nice flow to the piece.

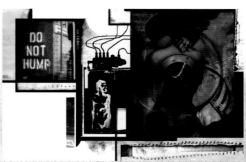

Verdure

While in LA walking through a parking garage, I suddenly felt compelled to look up. To my surprise there was an old speaker (long forgotten) just resting on the ceiling and falling apart. At that moment I realized how little I actually look around as I walk.

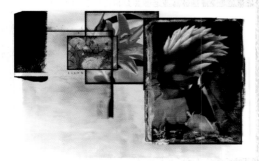

Siren

This was my first successful image created in Photoshop. It's a combination of a simple black mask, sea cucumber and long strips of metal. All the unrelated elements blended together harmoniously.

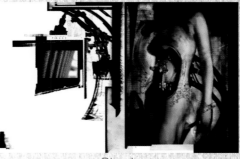

Diesel

I enjoy viewing engine manuals and the idea of performing an autopsy on one. It's amazing how each component needs to be fitted, arranged and ordered to complete an operational engine.

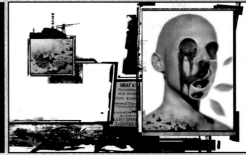

Ashen

The name *Ashen* means gray or extremely pale. There was no direct inspiration for this piece other than to play with shapes and the spare usage of color. While the blood does add an element of harshness, I always remind myself that the red color was derived from a picture of strawberries.

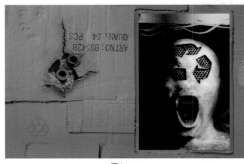

Triuse

There is a sense of impending doom unless we try to conserve and co-exist with nature. It's vital that we give in to conservation of natural resources and recycle.

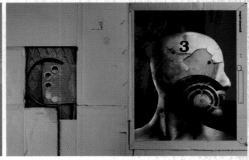

Troika

The number three has been an important symbol that appears in my life regularly. More and more I am seeing repetition of shapes that naturally occur in nature and in human-designed objects. Astronomy, chemistry, physiology, physics, history are all equally dependent on numerology.

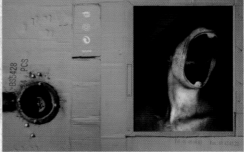

Lacuna

This is one of the few pieces that shocked me after I completed it. *Lacuna* confronts the thoughts of "How much of our identity is attached to our appearance?"

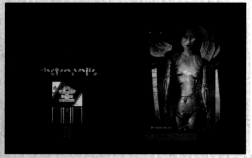

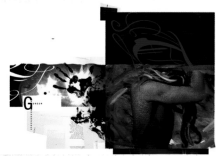

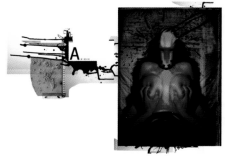

Metropolis

Greek for Mother City, this is my gritty interpretation of the *Metropolis* film.

Gorgon

The Greek mythological tale of Medusa has always been a great resource of ideas. The movie *Clash of the Titans* further solidified my admiration of Ray Harryhausen's unrelenting depiction of the gorgon. I've always wondered, what if Perseus bestowed the gorgon's curse?

Animus

Animus explores the harsh reality of women becoming overly depicted as objects and not as individuals. The refusal to recognize someone as an individual is profoundly disturbing.

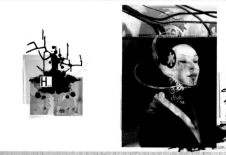

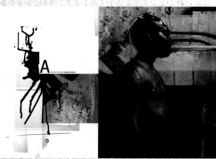

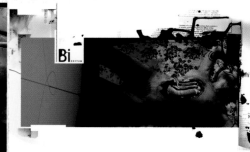

Halo

Halo ended up being more than I could have ever imagined. This image gives me hope for the future and a peaceful existence of man and machines.

Asphyxiate

Asphyxiate alludes to the suffocation we many experience if global warming and pollution continue at their current rate. There is a recycle symbol that emphasizes the importance of recycling and reducing waste.

Biorythm

Biorythm is not a real word, but works well for this piece because it alludes to a subtle detail that is easily overlooked.

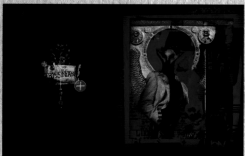

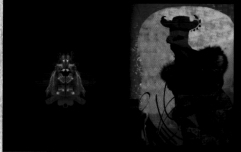

Abyssinian

Abyssinian has a face of a feline and a body of a human. In order to provide some color harmony, green leaves were added.

Marionette

There is something magical about a handcrafted puppet or marionette. In the right hands, they become alive and exhibit their own personalities.

Catenary

I discovered an old coin-operated mechanical horse, which children rode, labeled "The Champion." It was sitting outside of a grocery store and I thought, "What if there were coin-operated machines for adult women?"

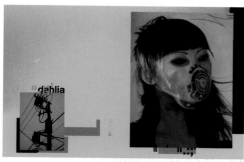

Dahlia

With *Dahlia* I tried to loosen up and allow accidental shapes and marks to stay in place rather than painting over them.

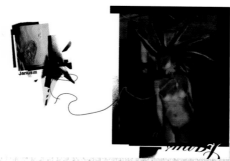

Janus

Janus was a breakthrough piece in which I started to develop a style and fortified a working methodology. Discovering a style is about creating tons of art, making mistakes and learning from them. During this process "happy accidents" will occur that help to define your unique signature style.

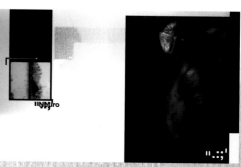

Neuro

At times, I tread a fine line between attraction and repulsion. Never intentional in approach, it comes down to utilizing shapes, colors and mood.

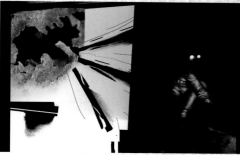

Desolation

The world can be a lonely and cold place. What really made this piece is the glowing eyes.

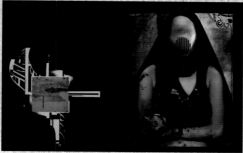

Abbess

Abbess combined a lawn mower, vent and a street light. The color and texture around the blade is intriguing.

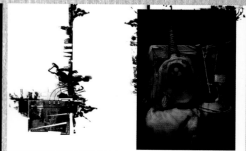

Ascend

Ascend started with a black canvas and worked up from there only using abstract patterns and shapes.

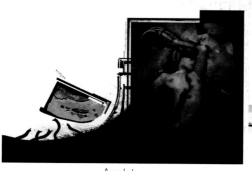

Acolyte

I've been spending more time studying old master paintings. I love how simple the strokes can be and how the colors vibrate. *Acolyte* was an attempt to create a sense of subtle motion and atmosphere.

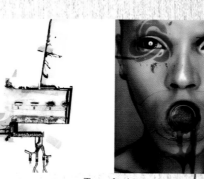

Transfusion

Transfusion is my favorite piece to date. Everything in this piece is symbolic and can be interpreted in so many different ways.

Ac**knowledg**ments

Publisher & Creative Director: **Raoul Goff**
Executive Directors: **Peter Beren and Michael Madden**
Art Director: **Iain R. Morris**
Managing Editor: **Jennifer Gennari**
Design Supervisor: **Melissa White**
Production Managers: **Noah Potkin and Lina Palma**
Production Editor: **Anne Pennypacker**

a special **thanks** to...

JS Rossbach. Already an established artist, illustrator and pioneer with design, I knew something wonderful was going to happen when he accepted my offer to work on the book. I supplied JS the drawings, photos, paintings and a small amount of direction. Little did I realize how much our sensibilities and styles were a harmonious match. He went above and beyond all expectations by designing innovative layouts that pushed the envelope of composition into a form of *Structured Beauty*. Without his artistic jewel case and devotion, this book would not shine as it does. From my heart, thank you **JS**.

Many **thanks** goes out to the following...

To **Kursad Karatas,** for showing me how to see the world through a lens and forever changing my perception.
Christopher Shy, thank you for the late night calls, collaborations, and motivation to keep going.
My wife **Olivia Lopez**, who understands me and is an exquisite second pair of eyes.
Jon Foster, for being an amazing person and a beacon of light when all seems dark.
Rick Berry, a constant source of inspiration, integrity and passionate work.
Iain McCaig, for believing in me when few did and having so much positive energy!
Iain Morris, for your support, insight and guidance.
Dave McKean, for showing me that art is without boundaries and endless.
To my **sister, brother and relatives**, thank you for a happy childhood and encouragement.
To **my parents**, even though I paint strange pictures, you have done a wonderful job raising me.

To all those who have influenced, inspired, befriended or supported me.

Chris Grun
Nat Johnson
Tony Diterlizzi
Scott Fischer
Brian Despain
Tim Bradstreet
Aaron Blecha
Justin Kaufman
Marko Djurdjevic
Aleksi Briclot
Jason Manley
Ashley Wood
John Matson
Jeff Miracola
Dan Milligan
Wesley Burt
Shawn Barber
James Daly
Paul Davies
Josh Hagler
Larry Snelly
Jason Sadler
Dave Stevenson
Dawn Marin

Melissa Rapier
Raphael Colantonio
David Goldfarb
Ray Gresko
Todd Kerpelman
Kelli Bickman
Alex Sheikman
Leif Jones
Seth Fisher
Beksinski
Brother Quay
Jan Svankmajer
Jenny Saville
Phil Hale
Hans Bellmer
Joseph Singer
Sargent
Jean-Leon Gerome
Dean Cornwell
Justin Sweet
Kent Williams
Bernie Wrightson
Glenn Barr
Dave Cooper

Barron Storey
Moebius
Bill Watterson
Robert ParkeHarrison
Joel-Peter Witkin
HR Giger
Diane Arbus
Ridley Scott
James Cameron
George Lucas
John Carpenter
Peter Jackson
Sam Raimi
Stephen King
Clive Barker
Flagship Studios
Massive Black Studios
ConceptArt
 Organization
Palace Press
 International
Random House
Baby Tattoo Books

Amon Tobin
A Tribe Called Quest
Bjork
Biosphere
Clicks&Cuts
Eluvium
Depeche Mode
The Cure
Jon Spencer
Loscil
Massive Attack
Misfits
Nine Inch Nails
Radio Dervish
Populous
The Prodigy
Skazi
Spylab
Sugar Plant
Thievery Corporation
Tool
White Stripes
80s music hits